The Campus History Series

COLUMBIA COLLEGE
CHICAGO

D1452179

Erratum and Addenda

P. 49: The college returned to Los Angeles in 1999 with the Semester in LA program, currently located on the premises of Raleigh Studios in Hollywood, California.

P. 90 (upper): The college purchased 600 South Michigan Avenue in 1975, not 1974.

P. 93 (upper): The college purchased 618 South Michigan Avenue in 2005.

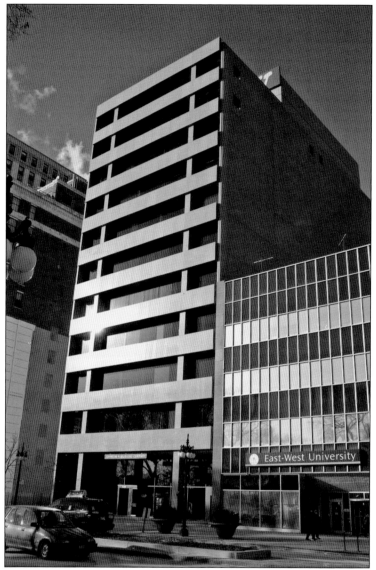

THE 820 SOUTH MICHIGAN AVENUE BUILDING. Built in 1972 as the headquarters for Johnson Publishing, this was the home of *Ebony* and *Jet* magazines for four decades. Designed by John Moutoussamy, this structure was the first major modern downtown Chicago building built by an African American. Originally clad in walnut travertine marble, it now features a granite facade. Purchased by the college in 2010, it will serve as the new home for the library, creating a research hub in the center of campus.

ON THE COVER: FILM SHOOT, c. 1950. One of the college's earliest mottos, "Learn to do by doing," is borne out in this studio film class. Students participate in all aspects of the film shoot, including directing, acting, filming, sound work, lighting, and script supervision. It is not known what is being shot in this particular photograph, but it was not unusual for students to also write original advertising copy or dramatic pieces.

The Campus History Series

COLUMBIA COLLEGE CHICAGO

R. CONRAD WINKE AND HEIDI MARSHALL
FOREWORD BY WARRICK L. CARTER, PH.D.

ARCADIA
PUBLISHING

Published by Arcadia Publishing
Charleston, South Carolina

Printed in the United States of America

Library of Congress Catalog Card Number: 2010938587

For all general information, please contact Arcadia Publishing:
Telephone 843-853-2070
Fax 843-853-0044
E-mail sales@arcadiapublishing.com
For customer service and orders:
Toll-Free 1-888-313-2665

Visit us on the Internet at www.arcadiapublishing.com

*R. Conrad Winke dedicates this book to Gavin,
a smile across a crowded life.*

*Heidi Marshall dedicates this book to her posse,
MEG, CCDM, BJM, CED, and SLD.*

*Both authors further dedicate this book
to Mary and Ida, for beginning the adventure.*

CONTENTS

ACKNOWLEDGMENTS

This book would not have been possible without the tireless assistance of so many campus and Chicago-area colleagues and our editors: Opal Anderson, Melissa Basilone, Alicia Berg, Catherine Bruck, Dr. Warrick L. Carter, Jo Cates, Paul Chiaravalle, Jan Chindlund, Diane Doyne, Fritz Eifrig, Paula Epstein, Dave Feiferis, Michelle Ferguson, Mary Forde, Kyle Henke, Colin Joyce, Steven Kapelke, Kristin Lipkowski, RoseAnna Mueller, National Lewis University Archives, John Pearson, Gavin Rehfeldt, Cole Robertson, Dominic Rossetti, Miklos Simon, Yvonne Sode, Frank Villella, Julie Volkmann, and Ann Wiens. We also wish to thank Dominic Rossetti for shooting the bulk of the modern photographs.

We have tried to include as much of the college's history as possible, but in a book of limited size, it is simply not possible to cover everything. We regret any omissions. Also, while we have tried to be as meticulous and accurate as possible, much of Columbia's past remains to be uncovered. We apologize in advance for any errors that may have crept into the text.

Unless otherwise noted, all images are from the College Archives and Digital Collections at Columbia College Chicago, and all proceeds from the sale of this monograph will go to support the preservation of materials in this collection.

FOREWORD

Putting together a book that outlines the history of Columbia College Chicago provides occasion to reflect on the common threads that run through the school's long history. Characteristics such as a commitment to creativity, an emphasis on learning by doing, and a deep respect for teaching have all been a part of the Columbia ethos throughout its many locations, evolving curriculum, and variety of leadership since its inception in 1890.

Columbia's founders established a coeducational school they said "should stand for high ideals, for the teaching of expression by methods truly educational, [and] for the gospel of good cheer." Although today I might use different vocabulary, I still wholeheartedly agree with those characteristics.

The words above were written by Mary A. Blood, who, with Ida Morey Riley, founded the college in 1890. I find it significant that Columbia was founded by two women. They established the institution against the wildly innovative and optimistic backdrop of the World's Columbian Exposition, the 1893 World's Fair that inspired Columbia's name. At that time, in the late 19th century, the college's founders did not even have the right to cast a vote in this country, yet they had the determination to envision and establish a college that offered enterprising women and men the many opportunities that a college education provided then, just as it does now.

As I write this, I am embarking on my 10th year of leadership of this wonderful institution. Like history book projects, milestone anniversaries provide occasion to reflect on the past, and as I look back on my decade as president of Columbia College Chicago, I am deeply honored to have the privilege of guiding the college into the 21st century.

Today Columbia College Chicago remains committed to offering access to higher education and the opportunities it affords to an incredibly diverse community of creative individuals. Each May, as I shake the hands of our newest cohort of graduates and hand them the diplomas they worked so hard to earn, I am overcome with pride and humility. I am humbled by the boundless creativity that surrounds me every single day on this campus, and I am delighted to share some of that with you in the images and stories collected in this volume.

Warrick L. Carter, Ph.D.
President, Columbia College Chicago

INTRODUCTION

Columbia College Chicago has been a leader in creative arts and communications education since opening its doors in the heart of the city more than 120 years ago. Founded in 1890 as a school of oratory to teach public speaking to men and women, Columbia soon adapted its mission to the new century's rapidly changing communication technologies. The school's modernizing direction was inaugurated by Norman Alexandroff and carried on by his son Mirron, or "Mike," who succeeded his father as school president. In 1964, Columbia emerged as a highly diversified and coeducational institution of higher learning, providing a comprehensive education coupled with training and professional opportunities in the arts, communications, and public information. From its birth to the present day, Columbia College Chicago has prided itself on its enlightened liberalism within the context of excellence and high expectation.

The Columbia School of Oratory was established in 1890 by Mary Blood and Ida Morey Riley, both graduates of what is now Emerson College, Boston, Massachusetts, to teach oratory, physical culture, voice culture, elocution, public school reading, dramatic action, visible speech, literature, and English by way of the Emerson principles. This was based on three basic methods: stimulating the cause (freeing the voice and body from habit to make them responsive agents of the mind); developing the organic means (performing exercises for voice, action, and interpretation to develop a mastery of essential forms of experience and corresponding actions for communication); and securing a better knowledge of the right modes of execution (such as proper posture, breathing, and articulation). Anticipating a strong need for public speaking at the 1893 World's Columbian Exposition, which celebrated the 400th anniversary of Christopher Columbus's arrival in the Americas, Blood and Riley were inspired to open their school in the exposition city, Chicago, and adopt the exposition's name.

Although secular and coeducational from the start, Columbia was influenced by Blood's religious convictions to focus on students' moral character along with their physical and mental development. Applicants were, in fact, required to provide satisfactory evidence thereof. The school offered Bible-reading classes and strongly encouraged weekly church attendance in promotion of a "sterling Christian character." The Women's Christian Temperance Union (WCTU), headquartered in Evanston, endorsed the Columbia School of Oratory as a central training school for temperance workers. Even though this ideological foundation has largely changed, the school's motto of *esse quam videri* ("to be rather than to seem") and its philosophies of "learn to do by doing" and "theory never made an artist" remain as vital today as they were well over a century ago.

Bachelor's and master's degrees, in addition to two-year diplomas, have been offered almost from the school's founding. Early on, enrollment included a large percentage of students-at-large as well as correspondence course students. Nine diplomas were conferred at the first graduation ceremony in 1892. Columbia's recognition by the Illinois State Examining Board qualified its graduates to teach English, vocal expression, and physical training in Illinois without specific state certification.

After Riley died unexpectedly in 1901, school officials incorporated the college on May 5, 1905, as the Columbia College of Expression. Despite this precaution, both the president and the vice president of the board of directors passed away during the first half of 1927, followed by Blood's sudden death that July. Within two months, the college relocated to the facilities of the Pestalozzi Froebel Teachers College (PFTC) and accepted students there for the fall term. On April 30, 1928, the school was chartered anew with the state by longtime faculty

and board member George Scherger, Herman Hofer Hegner of PFTC, and his wife, Irma Rowe Hegner, with the mission of "the teaching of expression in speech and otherwise, and allied subjects, and the granting of degrees for study therein." The 1928–1929 catalog names PFTC as a sister institution and lists Scherger as Columbia president and board member. Bertha Hofer Hegner, the founder and president of PFTC, also appears as a board member, and Herman Hofer Hegner, her son, is school registrar and faculty member. Both Hegners would serve as Columbia presidents after Scherger's 1929 resignation, a move prompted by his call to become a full-time pastor. Columbia and PFTC would retain their close affiliation until 1963, sharing administration, employees, curriculum, facilities, and two relocations.

The college's early curriculum addressed the communication needs of an era dominated by the pulpit, the lecture platform, the Chautauqua circuit, and the stage. However, revolutionary changes in communications before mid-century, including radio, sound motion pictures, and later, television, demanded curricular response. In 1934, Herman Hofer Hegner, then acting president, recruited lecture circuit veteran and radio producer Norman Alexandroff to establish instruction in radio. By 1937, Alexandroff was vice president of the college and a member of both the college and PFTC's board of directors, along with Herman Hofer Hegner and their wives. Together, Alexandroff and Hegner produced a study demonstrating that children were equally absorbed by educational radio programming and action/adventure programming, provided that the former was presented at the same dramatic tempo as the latter. The study also showed that children learn almost exclusively through dramatic impulses, and it brought national attention to both Columbia and PFTC.

In 1944, Columbia became a separate institution from PFTC, with Alexandroff as its board-appointed president. The various forms of names appearing in college publications throughout the 1930s were replaced by, simply, Columbia College. Columbia was certified by the Illinois State Examining Board for Teacher Education, which qualified the school to enroll GI Bill veterans. In 1944, Alexandroff coauthored *The Occupational and Educational Adjustment of Veterans*, a pioneering study on the effects of war on returning veterans. Consequently, the college was designated as one of 15 Veterans Guidance Centers in the United States and made free comprehensive testing, educational and occupational counseling, and psychological services available to World War II veterans. When television was added to the curriculum the following year, the school's emphasis on broadcast media made it a popular option for returning veterans and, at the same time, shifted the student body to a largely male population.

During the 1950s, Alexandroff relocated to California to found Columbia College Los Angeles and Columbia College Pan-Americano in Mexico City. Both of these institutions became fully independent of their Chicago parent by the end of the decade. Although Alexandroff remained president until his death in 1960, he left the Chicago operations under the de facto direction of his son Mike. During this time, the college's fortunes relied heavily on the GI Bills from World War II and the Korean War, but by 1961, when the younger Alexandroff became president, most of this funding was gone and enrollment had plummeted. Hegner, in response to Columbia's precarious situation, notified Alexandroff that PFTC would separate from Columbia at the end of 1963 and relocate to a new campus. All jointly shared staff, equipment, and curricula would accompany PFTC, leaving Columbia with few possessions, a reduced staff, limited curriculum, too much physical space, and an unsustainable business model. Ironically, while Columbia would go on to thrive independently, PFTC was wholly absorbed by the National College of Education in 1971, which through a subsequent merger became part of National Louis University.

This separation crisis precipitated the creation of the modern Columbia. Upon securing new property, Alexandroff's first priority became full undergraduate accreditation, achieved in 1974. Full graduate accreditation was awarded in 1984. Accordingly, the school left behind its resemblance to a trade school, while creating a program focused on the public arts and communication media within the format of a liberal arts education, encouraging students

to discover and integrate the two fields of study. The college was a pioneer in combining vocational preparation in the arts within a liberal arts framework and offering a hands-on learning experience under the guidance of recognized practitioners. This redefinition of the college's mission established the expectation that Columbia students can insightfully articulate contemporary issues and author the culture of their times. Likewise, the college affirmed its commitment to noncompetitive admissions and its view of the city-as-campus.

Success was immediate, marked by a tenfold rise in enrollment between 1964 and 1974, a figure that would triple by the decade's end. Space, once at a surplus, was now becoming a critical need, leading the college to purchase its first building and establish a permanent campus in Chicago's South Loop. The school was determined to remain downtown and adhere to its history as, in Alexandroff's words, a vertical "sidewalk college." After a search of several years, the college purchased the 600 South Michigan Avenue building in October 1975. Classes commenced at that location in early 1977. When Alexandroff retired in 1992, the properties at 624 South Michigan Avenue and 623 South Wabash Avenue had also been acquired, thereby establishing the central core of the new campus.

Dr. John B. Duff, college president from 1992 to 2000, oversaw the addition of a number of buildings, which expanded the campus significantly and included the modern college's first residence hall. Through his efforts, and those of the succeeding administration, the South Loop and Columbia College Chicago have become permanently intertwined. Today Columbia's campus occupies almost two-dozen buildings covering more than 2.5 million square feet. Such growth has proved instrumental in transforming the city's declining downtown from a skid row into the vibrant community that now exists. Duff also led the college in its first long-range planning effort and expanded both local and national development initiatives. During his tenure, the college changed its name to Columbia College Chicago.

Dr. Warrick L. Carter became the college's president in 2000. Under his leadership, Columbia has become the nation's largest school of arts and media, and one of the largest in the world, as well as being the second-largest provider of private undergraduate education in the state, with a 2010 enrollment of about 12,000 students. The curriculum reflects both the college's past and keeps pace with contemporary interests. Oral expression still shares a place in the catalog alongside theater, radio, film, and television, and students can explore the gamut of art experiences, from the ancient craft of papermaking to the future of video game development. Among the other significant achievements of Carter's tenure is the construction of the country's largest multi-college residence hall, in partnership with DePaul and Roosevelt Universities. This space has played a significant role in transforming the college from a commuter school to a 24-hour residential campus.

In 2007, the college merged with the 108-year-old Sherwood Conservatory of Music, an institution which also maintains a strong commitment to community service and engagement. In spring of 2010, the college opened the landmark Media Production Center, the first newly constructed building in the its history, and later that year, the college purchased the Johnson Publishing building at 820 South Michigan Avenue to serve as the library's new home.

Upwards of 60,000 students attend classes at more than 20 institutions of higher education in the Loop and surrounding neighborhoods, leading some to characterize the area as "the education corridor" or "Loop University." Columbia stands as a leader and key player on the state's largest campus.

While the Columbia College Chicago of today has evolved substantially from its Columbia School of Oratory origins, there are deep connections with its past. Its curriculum has always integrated imagination, originality, creativity, and individuality into the larger social trends, movements, and issues of the day. It has built upon its oratorical origins to creatively expand into new technical territories. Columbia College Chicago has truly lived its motto, *esse quam videri* ("to be rather than to seem"), as it has fostered a heritage of innovation and creativity to fully realize the abilities and aspirations of the students it serves.

One

ORATORY FOR THE FAIR

ADVERTISEMENT, 1890. Appearing in the August 25, 1890, edition of the *Chicago Tribune*, this is the earliest known mention of the college. The college's founders, Mary Blood and Ida Morey Riley, are listed as associate principals, but Blood had assumed the title of principal by 1893. The college did not have a telephone until 1909; the number was Harrison 633.

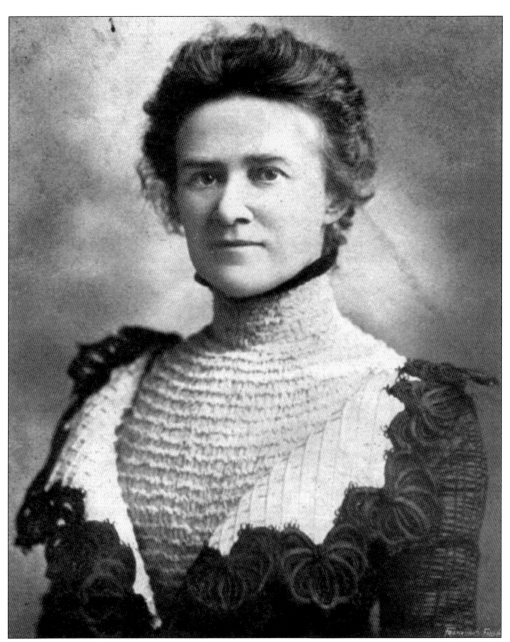

MARY BLOOD (1851–1927). Blood cofounded the Columbia School of Oratory in 1890. Born in Hollis, New Hampshire, to a farming family, she attended Framingham Normal School in Massachusetts. She taught at the Eliot School, founded in 1676, where the curriculum included sewing, art, cooking, and painting and was designed to "satisfy that instinctive desire of human beings to create." Educated at Boston's Monroe College of Oratory, she became a faculty member in 1883 and a member of its board of trustees in 1887. During her tenure, she traveled to Ames, Iowa, to teach at the State Agricultural College, where she met fellow instructor Ida Morey Riley. Blood served as president of Columbia until her death in 1927 and was active in the National Association of Elocutionists, the Women's Christian Temperance Union, and local community groups.

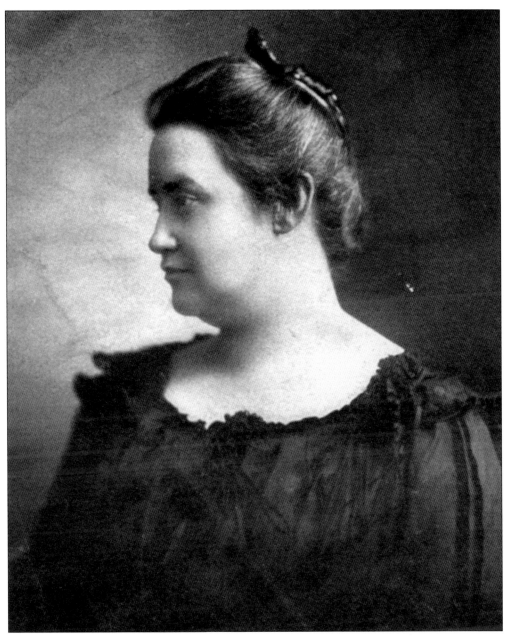

IDA MOREY RILEY (1856–1901). Riley cofounded the Columbia School of Oratory in 1890. Born in Mercer County, Illinois, her family moved to Union Township, Iowa, where they had a farm. When her husband, Heston Riley of Ohio, died of influenza in 1879, she moved back to Iowa and became the principal of the public school she attended as a youth. In 1887, while teaching at the State Agricultural College in Ames, Iowa, she met Mary Blood, who urged her to move to Boston and study at Monroe College of Oratory. Riley graduated with a bachelor's degree in oration in 1889 and a master's degree in oration in 1890 and then joined Mary Blood in Chicago to found Columbia. She was active in the National Association of Elocutionists and was a member of its board of directors until her death.

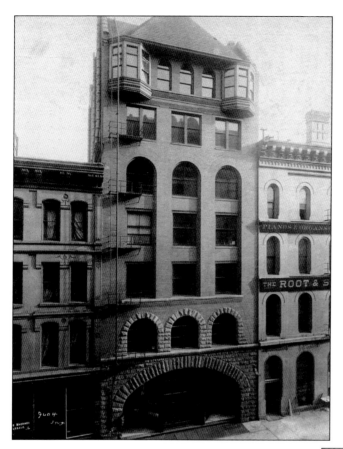

THE STEVENS ART GALLERY BUILDING, 24 (NOW 57–59) EAST ADAMS STREET. The college's first home was the Stevens Art Gallery Building. Built in 1888 of steel-frame construction and clad in granite and Roman brick, this Queen Anne–style building by Pond and Pond originally housed an art gallery, a store, and offices for artists, musicians, and fashion designers. The college moved out in 1895, and it was demolished sometime before 1949.

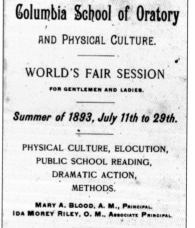

COLUMBIAN EXPOSITION CATALOG, 1893. With coursework designed around the fairgoer's schedule, this summer session offered classes in physical culture, voice culture, elocution, and literary interpretation and methods. These morning sessions lasted from 9:00 a.m. to 12:30 p.m., giving students the opportunity to visit the exposition in the afternoon and evening. Tuition for 60 lessons and 12 lectures was $18 and included a personal guide to shepherd a summer student around Chicago.

STEINWAY HALL, 64 EAST VAN BUREN STREET. This was the college's home from 1895 to 1916. It occupied the entire seventh floor and eventually had a gymnasium on the sixth. Blood's office was the bay window on the right-hand side of the seventh floor. The building was occupied for many years by the Chicago Musical College and was razed in 1970 to make way for the CNA Center. (Courtesy of Chicago History Museum.)

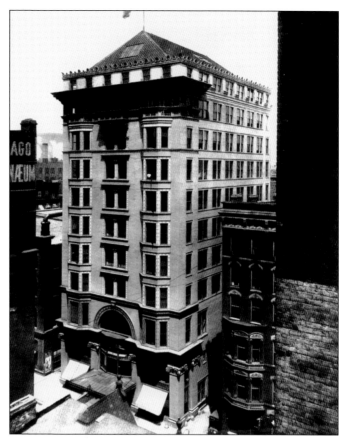

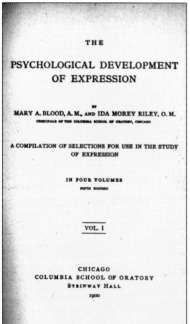

THE PSYCHOLOGICAL DEVELOPMENT OF EXPRESSION, **1900.** Edited by founders Mary Blood and Ida Morey Riley, this four-volume set of books taught students not to merely speak, but to convey ideas. Using written excerpts from great English literature, students were taught to train the voice and use the body to communicate powerful ideas through dramatic oration.

15

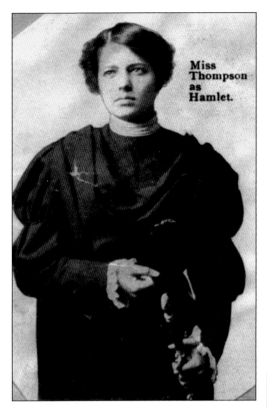

Miss Thompson as Hamlet.

HAMLET, 1900. Mary Thompson of Pontiac, Illinois, class of 1900, played Hamlet in a Columbia School of Oratory production. The school taught classical drama courses that concluded with a theater production. The study of oration included learning the skills of public speaking and body movement, which mesh well with theater. Today Columbia annually produces hundreds of dance, theater, and music performances, along with television programming and lectures.

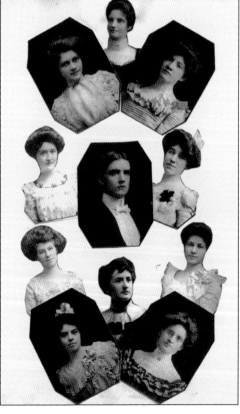

COLUMBIA CLASS OF 1901. The Columbia School of Oratory class of 1901 graduated four men and 20 women on May 4 at Steinway Hall in Chicago. Two students completed the four-year professional course, two earned degrees through the two-year public readers' course, and 20 students completed the two-year teachers' course. Students came from Illinois, Wisconsin, Iowa, Michigan, Minnesota, Colorado, Oregon, and California to attend the school.

COLLEGE SEAL, 1905. The school has held several different names. In 1890, it was Columbia School of Oratory, and in 1905, it was incorporated as Columbia College of Expression. One classroom motto, "learn to do by doing," quoted from Aristotle, became part of the school seal. Another 1905 Columbia classroom motto was "theory never made an artist," a concept that the college still upholds today.

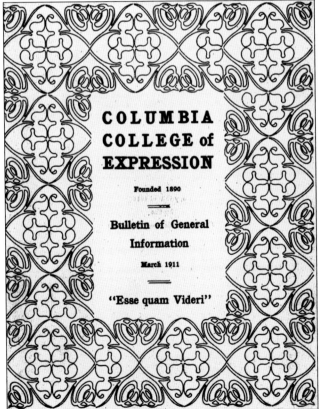

CATALOG, 1911. The cover of this college catalog prominently features the school motto *esse quam videri* ("to be rather than to seem"), a phrase from Cicero's work *On Friendship*, or *De Amicitia*, chapter 26. Cicero is one of the authors that Mary Blood and Ida Morey Riley highlighted in their four-volume work *The Psychological Development of Expression*, published in 1894 and reprinted in 1900.

Junior A Junior B Junior C

18

CLASS SCHEDULE, 1911. Classes were mapped out for each day of the week on a 17-inch-by-22-inch piece of paper. Discovered inside a copy of the 1911 catalog, this piece was written in longhand by Mary Blood and illustrates the spring 1911 Tuesday classes for the 53 junior-year students. Names of the class and the teacher are shown. Classes offered included the following: Bodily Expression (the study of body movements to convey emotion); Tone and Language (proper breathing and voice resonance work); Development of Expression (using body, voice, and tone to convey emotion and ideas to an audience); Physical Education (exercise to develop body, health, bearing, and grace); Voice (cultivating mobility of the vocal organs); Storytelling (practicing the art of telling stories); and English (studying great writers to inspire creativity and imagination).

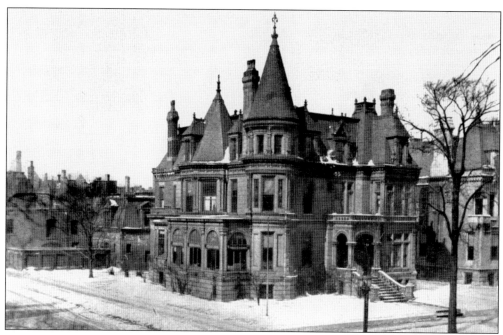

THE RELOCATION TO 3358 SOUTH MICHIGAN AVENUE. Depicted in the 1923 catalog, this mansion, built by meatpacking magnate Charles Libby, was rented to the college by Libby's widow and served as the college's home from 1916 until 1925. It was initially used as classroom space, administrative offices, and a dormitory. A second building on the property housed the Columbia Normal School of Physical Education, of which scant information is known.

3358 SOUTH MICHIGAN AVENUE, 2010. After 1925, the mansion changed hands a number of times, eventually being subdivided into apartments. In December 1951, it suffered a serious fire and was demolished the following year. Subsequently, the property, along with a portion of Thirty-fourth Street, was absorbed into the campus of the Illinois Institute of Technology, which built the Triangle fraternity house on the site in 1959.

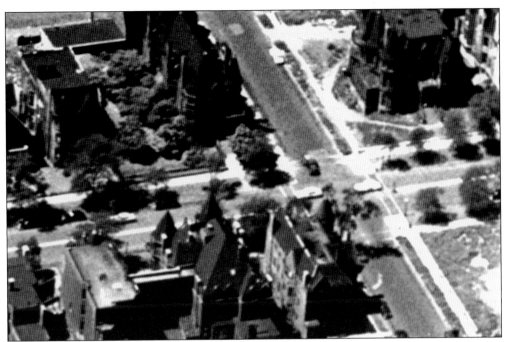

INTERSECTION OF MICHIGAN AVENUE AND THIRTY-FOURTH STREET. This view, looking northwest, shows 3358 South Michigan Avenue in the upper right. In the lower left, connected by a bridge, 3409 and 3415 were rented as dormitory space and named Riley and Colledge Halls. These mansions, along with one across the street at 3400, were built by the Mandel brothers, owners of one of the city's largest department stores. (Courtesy of IIT Archives Chicago.)

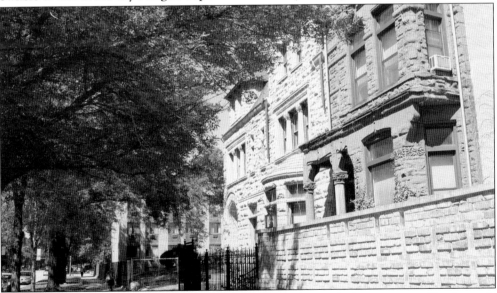

3400 BLOCK OF SOUTH MICHIGAN AVENUE, 2010. Both 3409 and 3415 were razed by the early 1970s. The Boulevard Care Center nursing home, seen in the background, now occupies the site. As this photograph shows, some of the historic residential architecture in this neighborhood survives today. Mandel Brothers was bought out by Wieboldt's in 1960. Its flagship store, at State and Madison Streets, now houses T. J. Maxx and Filene's Basement.

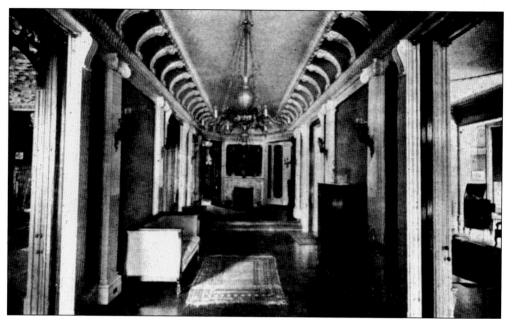

RECEPTION HALL, 1916. This reception hall was located within 3358 South Michigan Avenue. The residence was home to female students who did not live within traveling distance of the college. Accommodations for male students were found at nearby boardinghouses. In this setting, women learned social responsibilities and honed practice in the great art of making a delightful home.

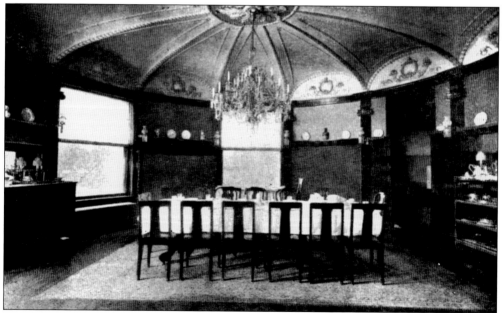

DINING ROOM, 1916. Located within 3358 South Michigan Avenue, this dining hall encouraged female students to cultivate friendship, learn proper manners, and socialize. Board cost $175 per academic year. Dinner was served promptly at 6:15 p.m. If students stayed during holiday breaks, food costs were $7 per week. Alcohol was never served, as the school was endorsed by the Women's Christian Temperance Union.

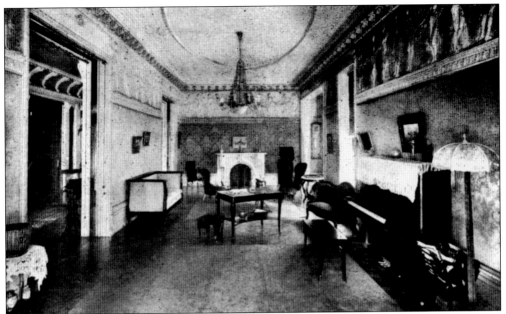

MUSIC ROOM, 1916. By 1916, Chicago was a center for music and art. The 3358 South Michigan Avenue residence contained its own music room where female students could practice piano, sing, or simply socialize. Gentlemen callers could visit the residence and were received on the first floor only on Saturday evenings; they had to leave by 10:00 p.m. Lights out for the home was at 10:30 p.m.

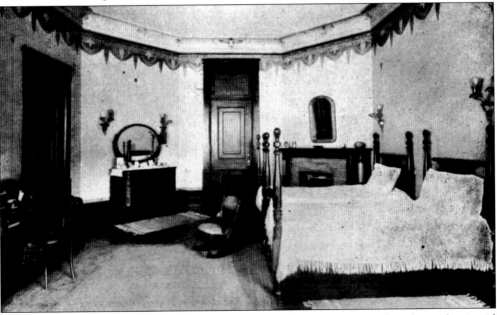

BEDROOM, 1916. To rent a room at 3358 South Michigan Avenue, a female student paid between $60 to $140 per academic year. Rooms were furnished with curtains, a bed, pillows, a bureau, a chair, and a study table. Each student was required to furnish a neutral-color rug, sheets, bedding, towels, a wastebasket, six cloth napkins, and a napkin ring. Laundry service was not included.

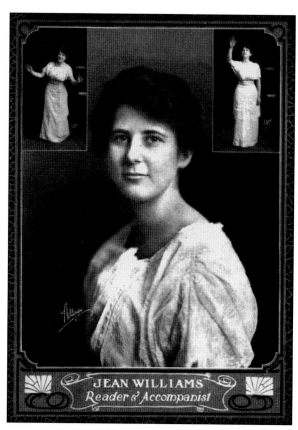

JEAN WILLIAMS
Reader & Accompanist

COLUMBIAN ENTERTAINERS, 1911. Class of 1912 graduate Jean Williams performed with the Columbian Entertainers on the Chautauqua circuit. Columbia College of Expression offered coursework for those interested in performing in various locations around the Midwest, booked through the Redpath Lyceum Bureau. College board president William A. Colledge was also president of the Department of Education at Redpath Lyceum Bureau. Columbian Entertainers performed vocal and instrumental solos, readings, and ensemble numbers.

CORRESPONDENCE BOOKLET, 1918. Columbia College of Expression published a correspondence series focusing on public speaking skills. Authored by R. E. Pattison Kline of Columbia's public speaking department, this image illustrates the incorrect posture for standing in front of an audience. The correct posture is hands at the sides, feet close together, and back straight. These booklets included lessons to be mailed to the college for feedback from Columbia instructors.

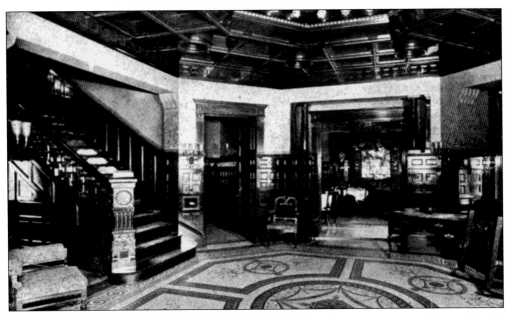

RECEPTION HALL, 1922. Across from the main college building were two residences female students were required to stay at if not already living in Chicago. The residences at 3409 and 3415 South Michigan Avenue were Ida Morey Riley Hall, named after the cofounder of the school, and Colledge Hall, named after William A. Colledge, president of the board. The reception hall offered a gracious space to greet visitors.

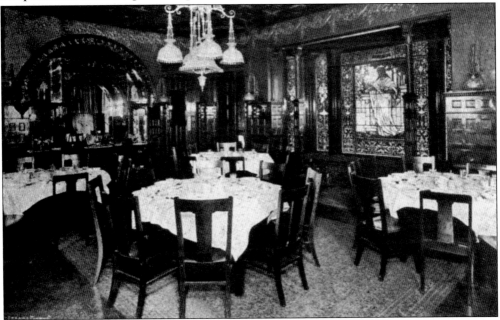

DINING ROOM, 1922. Fees for room and board were combined by this time. Estimated expenses were $350 per academic year, dependent upon the location of the room and the number of occupants in the home. No alcohol was served, as the school was endorsed by the Women's Christian Temperance Union. In fact, clergy, WTCU workers, and theological students received a 50 percent discount on all class lessons and tuition costs.

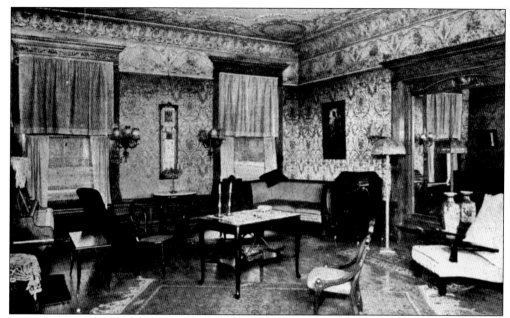

MUSIC ROOM, 1922. This room was used to practice music, sing, or socialize. Residents were allowed to go out two evenings per week, but only one in the company of gentlemen. All guests now had to leave by 10:15 p.m., and lights out was at 10:30 p.m. Any resident whose lights were on past this time had to pay a 10¢ per hour fee.

BEDROOM, 1922. Rooms were furnished, but laundry service was not offered. Students were encouraged to send their laundry home via parcel post for cleaning. The school required clothing to be simply made and permit free body movement and full use of the voice. Students were warned that failure to heed this caution would seriously impede their progress.

COLUMBIA CLARION, **1920.** The college paper was published four times a year. Student staff was chosen by the senior class and operated under a faculty editor. The paper published current college news, alumni news, and information for readers, teachers of vocal expression, and physical directors. This issue offers poetry, college news, class notes, alumni news, and advice, with the inside covers containing advertising from local businesses.

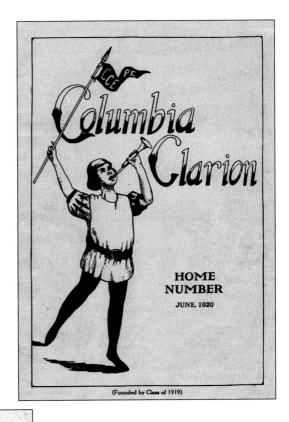

HOME NUMBER

JUNE, 1920

(Founded by Class of 1919)

ALUMNI LUNCHEON

Friday, June 11th, 1926, at One o'Clock

"THE DRAKE"

PROGRAM

GreetingsDr. George L. Scherger

Minutes of the Last Annual Alumni Luncheon
 Mrs Florence C. Armington, Secretary of Alumni.

Words of Welcome to the Class of 1926....
 Mrs. Anna Schaedler

Response from the Class of 1926..........
 Miss Helga Lund

Silver Anniversary Class of 1901..........
 Miss Claudine Coolidge

"Thirty Years Old Today"—Class of 1896

"Just 13"—Class of 1911....Elizabeth Graybeal

"Our Duty to the Scholarship Fund".......
 Mrs. Isabel Stambach

Roll Call of Classes.....................
 Mrs Phoebe Roberts Hedrick, President Alumni.

Au revoir Anne Larkin

Luncheon $2.00. Send reservations to Mrs. Phoebe Roberts Hedrick, at 120 East Pearson Street, before Friday or telephone Superior 0003.

ALUMNI LUNCHEON, **1926.** Active since 1895, the Columbia Alumni Association produced quarterly publications, held social events, and raised money for six college scholarships. In the 1920s, this luncheon program celebrated class anniversaries and, given the nature of the school, scheduled several speeches. One speaker of note was George L. Scherger, a faculty member at the college who became its president in 1927.

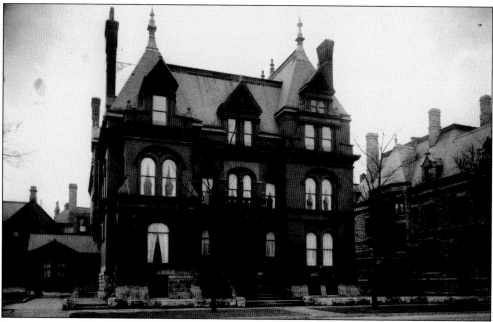

THE RELOCATION TO 120 EAST PEARSON STREET. Relocating here "to have an environment in harmony with its cultural ideals," this was the college's home from 1925 until 1927. Built in 1882 by Charles Farwell, a prominent merchant and real estate magnate, the house was designed by Treat and Foltz and was noted for its Queen Anne style and modern heating and plumbing. Farwell's brother John built the mansion next door to the east. (Courtesy of Chicago History Museum.)

120 EAST PEARSON STREET, 2010. Mary Blood passed away at this location. After the college moved out, it became Chez Louis restaurant. John Farwell's house was demolished in the 1920s when Michigan Avenue was widened, and Charles Farwell's home was razed in 1947 to make way for the new Bonwit Teller store, now a Borders bookstore. The site is immediately north of the Water Tower, Chicago's most famous landmark.

Two

AT THE VANGUARD

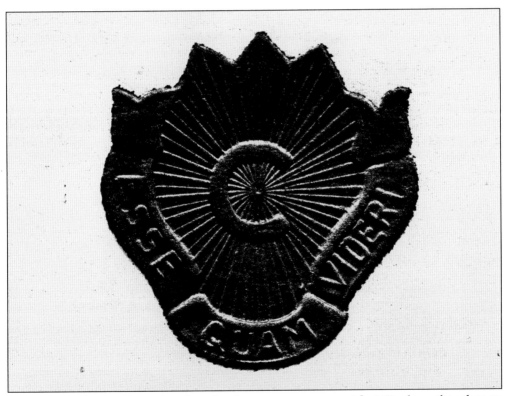

SEAL, 1928. This seal contains the school motto *esse quam videri* ("to be rather than to seem"). Its design incorporates sun rays, symbolizing creative energy. This seal marks a change for the school, as two months before fall 1927 classes began, founder Mary Blood died and the college moved to a new location with its sister institution, the Pestalozzi Froebel Teachers College.

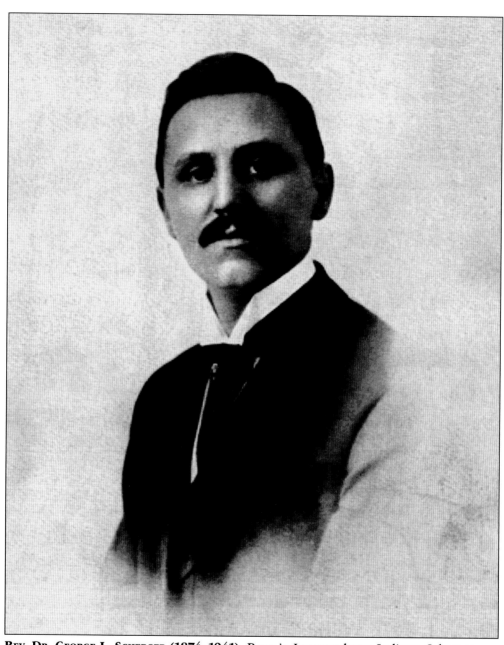

REV. DR. GEORGE L. SCHERGER (1874–1941). Born in Laurenceburg, Indiana, Scherger was educated at the University of Indiana, the University of Leipzig, and the University of Berlin, Germany, and received his doctorate from Cornell University in 1899. He was a minister, musician, writer, historian, and educator. A professor of history at the Armour Institute of Technology (now Illinois Institute of Technology), he also taught English and English literature at Columbia College of Expression. In the early 1920s, he became dean of the Departments of History, Public Speaking, and Public Debate and Lectures at Columbia and served as a member of the board of trustees. Scherger became president after the death of Mary Blood in 1927, serving until 1929, when he was appointed assistant pastor of St. Paul's Evangelical Lutheran Church, the oldest German church in Chicago at the time.

THE ARCADE BUILDING, 616 (NOW 618) SOUTH MICHIGAN AVENUE. After Blood's death, the college relocated to the Pestalozzi Froebel Teachers College's offices in the Arcade Building. Built in 1913 and designed by William Carbys Zimmerman, the building got its name from the furriers, millineries, and garment makers on its first two floors. In addition, it housed publishers, the American Red Cross, and the colleges. The original grid-like facade featured large windows and minimal masonry surfaces.

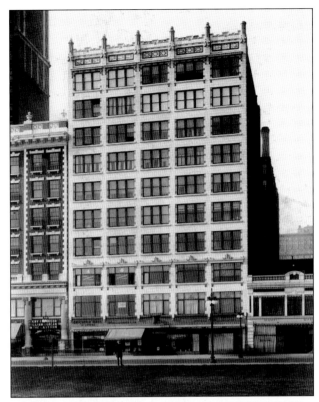

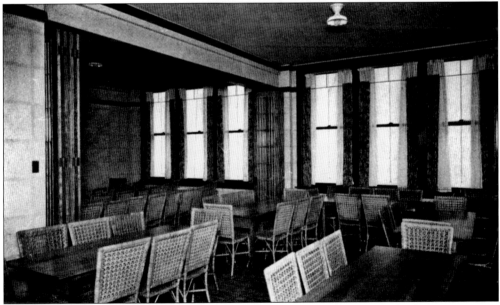

DOUBLE CLASSROOM, 1928. Pictured is a section of a double classroom with leaded windows and folding doors. This classroom allowed light and ventilation to be maximized for student comfort. The walls held Japanese murals, and the free flow of the room allowed for practical arrangement of furniture to suit many purposes, including classroom instruction, a gymnasium, or audience seats for a theater production.

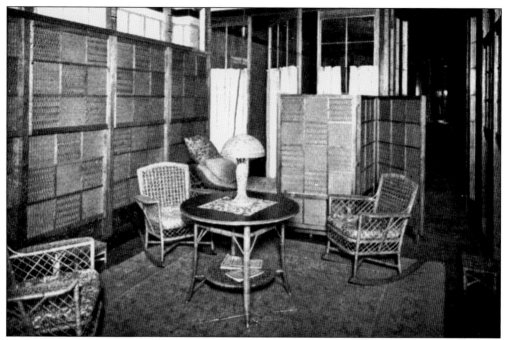

STUDENT LOUNGE, 1928. This cozy corner of the student lounge, where students took breaks between classes, was known for comfort and conversation. Additional space to store hats and cloaks was behind the folding screens. The wicker furniture, identified in a scrapbook as "Queene Ferry Coonley equipment," may have ties to the famous progressive educator and her husband, Avery Coonley, who established the Kindergarten Extension Association.

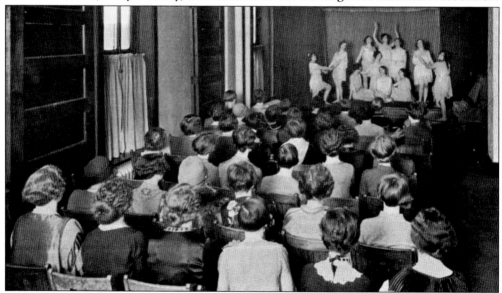

THEATER, 1928. This tableau, or living picture, shows a student production held in the college's Little Theatre. Other performances included plays, dancing, dance dramas, storytelling, and puppet shows. The images from this year were all shot within the Arcade Building, 618 South Michigan Avenue. The Columbia College of Expression and the Pestalozzi Froebel Teachers College were located on its seventh floor.

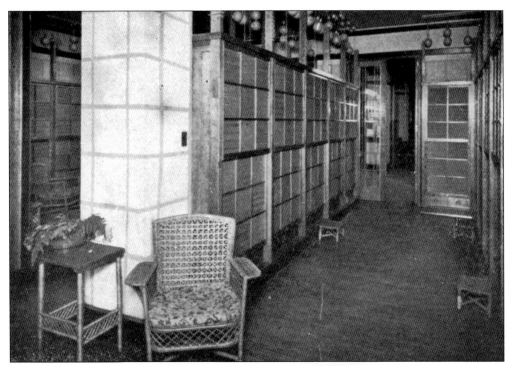

CLOAKROOM, 1928. Here is a section of the hallway and cloakroom in the Arcade Building. Lockers, hatboxes, and cloak racks were available for students. Adjacent to this area was the gymnasium, used for physical education, lectures, and assemblies, with leaded-glass partitions that could fold together to make two smaller instruction rooms.

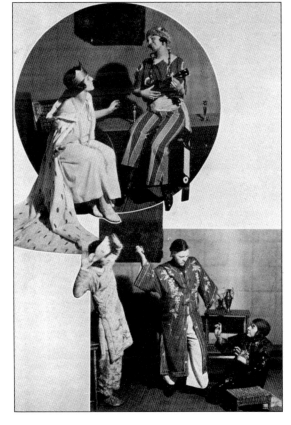

TEN MINUTES BY THE CLOCK, **1928.** Enacted are scenes from *Ten Minutes by the Clock*, a children's play by Alice Riley. It recounts the queen's escape and eventual return to traditional living. Her declaration of freedom begins by refusing the kingdom's traditionally decreed three-minute egg for breakfast and demanding a ten-minute egg instead. Characters include the king, the queen, and a cook named Bitter-Batter.

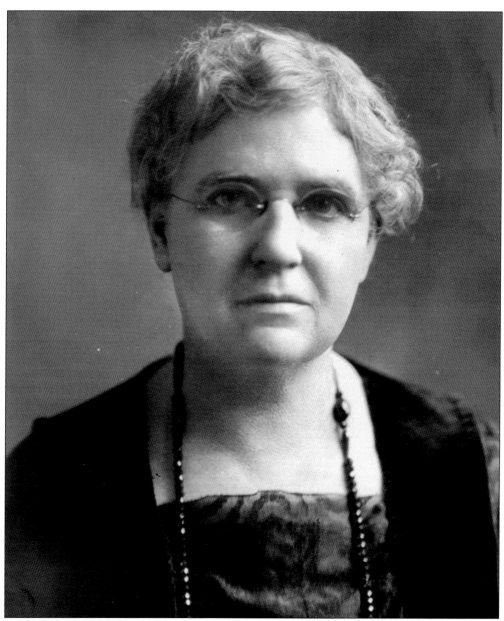

BERTHA HOFER HEGNER (1862–1937). Born in Claremont, Iowa, to the family that published the *MacGregor News,* Hegner was educated at the National Kindergarten and Elementary College in Chicago; the Pestalozzi-Fröbel-Haus, Berlin, Germany; the University of Chicago; and Columbia University, New York. She established the first kindergarten at the Chicago Commons Social Settlement and then founded the Pestalozzi Froebel Teachers College in 1896. After the death of Mary Blood, she assumed responsibility for the Columbia College of Expression, with both schools remaining independent institutions, and served as president of Columbia from 1929 until 1936. Hegner was a member of the International Kindergarten Union, the Illinois State Kindergarten-Primary Association, the Central Country Childhood Education, and Delta Phi Upsilon as well as the author of the monograph *Home Activities in the Kindergarten* for the U.S. Bureau of Education.

HERMAN HOFER HEGNER (1902–1973). Born in Chicago, Illinois, Hegner was the son of Bertha Hofer Hegner and Herman Frederick Hegner, a Congregational minister. He served as acting head of both the Pestalozzi Froebel Teachers College and Columbia from 1930 to 1936, when he was named president of both institutions. Hegner served as Columbia president until 1944, when Columbia officially separated from PFTC. However, the two institutions remained close and shared staff, faculty, and resources until 1963. He also oversaw the development of Columbia's radio curriculum in the 1930s and coauthored research in 1939 with Norman Alexandroff, focusing on how radio affected children's learning, whereby the men found children learn best through dramatic impulses. He was active in the National Artists Foundation, serving on its board in the 1940s.

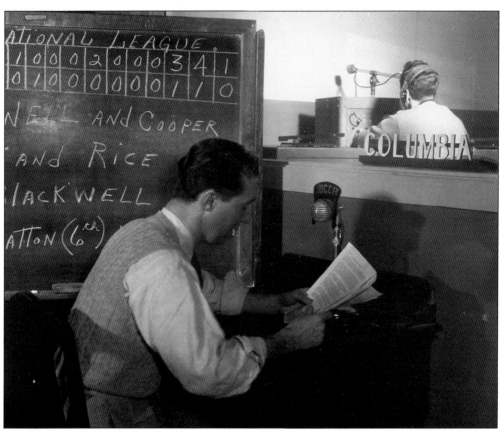

RADIO PROGRAM, 1934. The college established a radio department under the direction of Norman Alexandroff. Early classes ranged from radio technique and mechanics to writing news or sports stories for broadcast. Local stations hosted Columbia students for on-the-air practice, with programming as diverse as farm reports, news, entertainment, and sports. By 1938, the college had three radio studios and classrooms in the Fine Arts Building Annex.

LOGO, 1938. An earlier logo reflecting the dramatic arts was combined with a radio microphone to reflect the new direction of the college in the 1930s. Throughout the decade, the college variously went by Columbia College of Speech and Drama and, later, Columbia College of Speech, Drama, and Radio.

Norman Alexandroff (1887–1960). Born Nime Kulczinsky in Kishinev, Russia (now Chişinău, Moldova), Alexandroff was educated at home. Fleeing the infamous Kishinev pogrom, he immigrated to America in 1904, settling in Philadelphia, Pennsylvania, and changed his name to Norman Alexandroff. With William Dean Howells, he organized reading centers for foreign-born people and also founded the Literary Association of America. He starred in radio programs, prompting Herman Hegner to hire him to develop a radio curriculum at Columbia in 1934. Alexandroff became president in 1944, when Columbia separated from the Pestalozzi Froebel Teachers College, and he coauthored two important studies. Under his tenure, Columbia College became one of 15 Veterans Guidance Centers in the United States, making comprehensive testing, educational and occupational counseling, and psychological services available to World War II veterans. He also established Columbia College Los Angeles, California, and Columbia College Pan-Americano, Mexico City, Mexico.

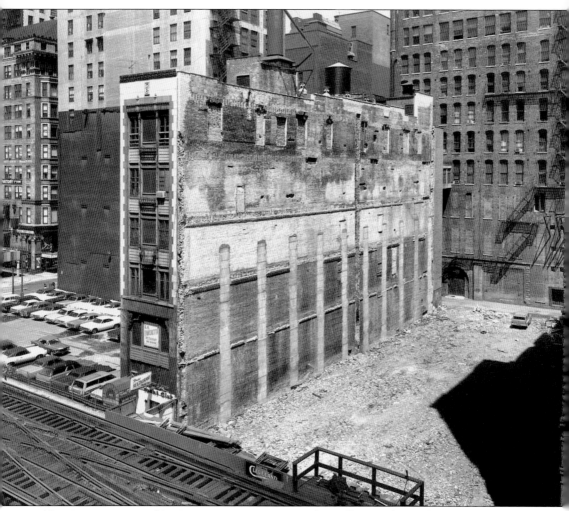

THE RELOCATION TO 421 SOUTH WABASH AVENUE. The colleges relocated to this site in 1937, occupying the second and fifth floors. This building, sometimes called the narrowest in the Loop, was designed by Andrew Rebori and built in 1924. It was demolished in 2010. Its facade, however, is preserved and will be incorporated into the new structure Roosevelt University is building on the site. The west annex building connected to the main Fine Arts Building on Michigan Avenue via a footbridge on its fourth floor, which is visible in this photograph. The colleges expanded into the main building in 1945 in anticipation of the influx of GIs as the war concluded and remained in both buildings through the summer of 1953. Also visible in this picture are 59 East Van Buren Street (immediately to the left of 421), a 1930 Holabird and Root design, which has served as the Buckingham dormitory since 2007, and farther to the left, Steinway Hall at 64 East Van Buren Street (see page 15). (Photograph by Chicago Architectural Photographing Company; courtesy of University of Illinois at Chicago Library, Special Collections, Chicago Photographic Collection, CPC_2_D_694_D_9928.)

VETERANS ADMINISTRATION

Hines, Illinois

October 6, 1945

YOUR FILE REFERENCE:

IN REPLY REFER TO: VRA

Mr. Norman Alexandroff
President
Columbia College
410 S. Michigan Boulevard
Chicago, Illinois

Dear Mr. Alexandroff:

Confirming Mr. L. W. Bartlett's understanding with you in conference October 5, it is planned to open the Veterans Administration Guidance Center at Columbia College October 15.

Space for the vocational adviser in charge and stenographer is to be provided by the College in accordance with contract concluded with Mr. Kane.

Desks for vocational adviser and stenographer and typewriter will be furnished by the Institution at present. Later, if the Institution finds that it must use this equipment for other purposes, the question of replacing equipment will be taken up at that time.

The Veterans Administration will furnish letter file and other supplies necessary for use of the staff.

Very truly yours,

C. E. HOSTETLER,
Chief, Vocational Rehabilitation and
Education Division

VETERAN'S ADMINISTRATION LETTER, 1945. Columbia offered educational, occupational, and psychological assistance for returning World War II veterans with the establishment of the Veterans Administration Guidance Center at the college. Part of the GI Bill, this guidance program counseled returning veterans about career and education choices. The center counseled more than 20,000 individuals from 1945 until 1956. Contracts with the Veterans Administration were renewed annually for equipment, space, and services. Columbia called this service the Department of Guidance and Research, as it also operated a scientific investigative arm and testing center that looked into sociological, educational, and psychological problems associated with commerce, industry, radio, and public affairs. It was staffed with counselors, psychologists, and statisticians, and the departmental findings gained national recognition. Of particular significance were the studies of listeners' response to radio, the comparison of occupational adjustment of veterans, and the comparison of World War II veterans and nonveterans in social and personal adjustment. This last study was lauded in the *Congressional Record* by Sen. Alexander Wiley (Republican, Wisconsin) on June 25, 1945.

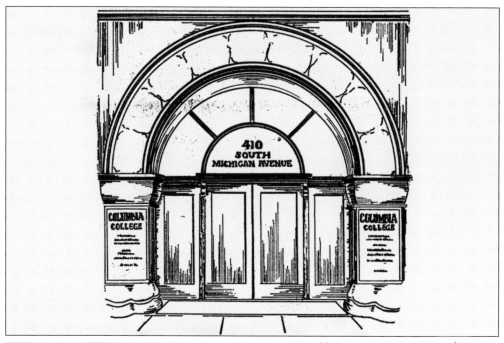

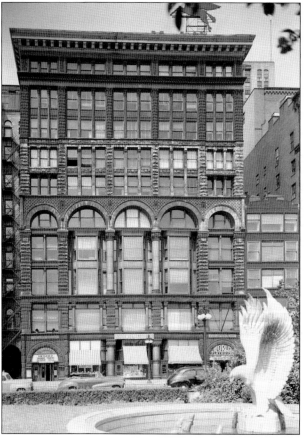

THE FINE ARTS BUILDING, 410 SOUTH MICHIGAN AVENUE. The Fine Arts Building was designed by Solon S. Beman and constructed in 1885. The building was originally owned by the Studebaker Corporation and operated as a warehouse and showroom for their wagons and carriages. In 1895, the company relocated their operations to 623 South Wabash Avenue (see page 100) and asked Beman to convert the structure into Chicago's first artists' colony. At that time, the upper three floors were added to the structure. The illustration above, taken from the 1947 catalog, depicts the college's name flanking one of the landmark's arched entryways. At left, a sign bearing the college's name appears over the center entrance. (Left, photograph by Chicago Architectural Photographing Company; courtesy of University of Illinois at Chicago Library, Special Collections, Chicago Photographic Collection, CPC_2_D_612_A_2758.)

JOURNALISM DEPARTMENT, 1947. Both journalism and advertising had been taught within the disciplines of radio and television, but it was not until 1947 that the Department of Advertising and Business and the Department of Journalism were established. Added in response to the increased enrollment due to the GI Bill, these new areas of study were in high demand. Pictured here is a typical newspaper page layout process.

ADVERTISING AND BUSINESS DEPARTMENT, 1947. By this time, advertising had become an important tool for business, with more than $3 billion spent annually in advertising media. The college also offered practical business subjects to prepare students for work in large and small businesses. Coursework included advertising, copywriting, layout, market research and analysis, business organization, business psychology, personnel relations, public relations, publicity, salesmanship, and business and creative writing.

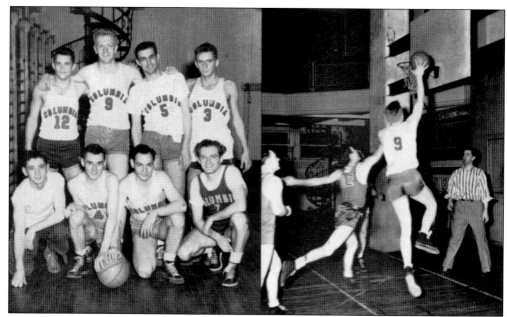

BASKETBALL TEAM, 1948. The influx of GIs led to the establishment of athletic programs. During the 1940s and 1950s, the college had a basketball and a softball team. Games were played off campus in gymnasiums around the city. These mid-century athletic programs also represent an institutional continuation of the emphasis Mary Blood placed on physical education and fitness. There are currently more than a dozen active sports teams on campus.

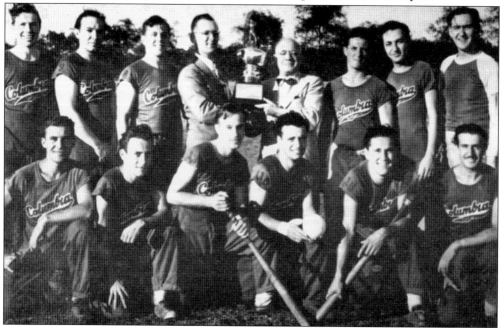

SOFTBALL CHAMPIONS, 1948. Norman Alexandroff proudly holds up the trophy won by Columbia's champion softball team, which played in Grant Park. The team's jerseys sport yet another Columbia script. What became of the trophy is unknown. Softball was first played in Chicago in 1887.

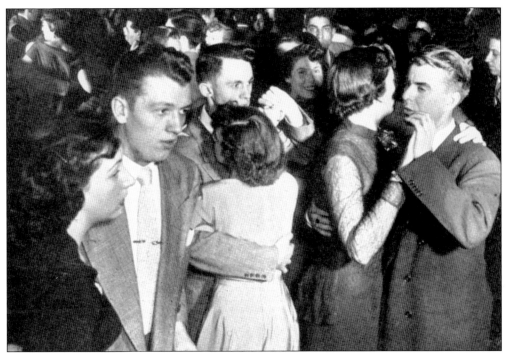

COLLEGE DANCE, 1951. The college maintained a regular schedule of dances, socials, and student-faculty events throughout the school year. These traditions continue today with events such as the Blood Ball (named in honor of college founder Mary Blood), student-faculty sporting events, and the activities of more than 60 officially recognized student organizations.

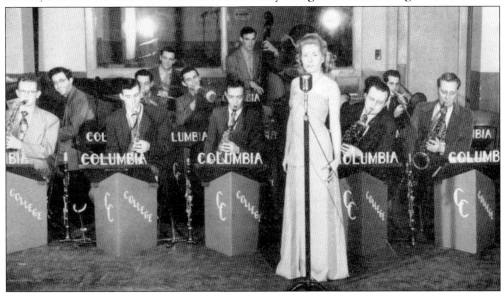

COLUMBIA COLLEGE BAND, 1948. Music did not play a big part in the college's curriculum during its first half century; however, music theory and music public school instruction had been offered as far back as 1905. During the 1940s and 1950s, courses in music appreciation were listed in the catalog. By the mid-1940s, the college had a choral club and a large band that provided music for college dances.

COLUMBIA DIAL STAFF, 1951. Pictured is the editorial staff of the *Columbia Dial* newspaper. Staffed by students from various college departments, the *Dial* reported news about alumni, sports, social events, and features. Later, in the 1980s and 1990s, there was *RE:* and, in 2002, *Gravity.* Today *DEMO* is the alumni publication and the *Columbia Chronicle* is the college newspaper. The college also publishes newsletters and scholarly journals.

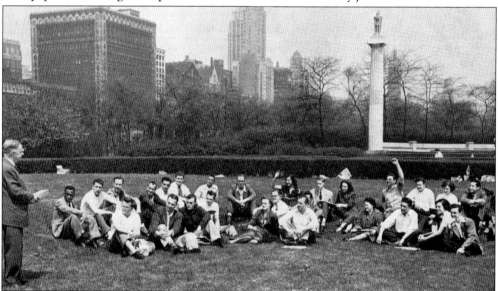

AL FRESCO INSTRUCTION, 1951. In a scene that is quite familiar to contemporary eyes, instructors and classes took advantage of Grant Park, which was adjacent to the campus. It is interesting to note that of the 27 students pictured here, six are women and one is African American. In that era, the fields of radio, television, journalism, and advertising were difficult for women and minorities to enter into.

LEARNING BY DOING, 1951.
Then as now, the college
has consistently employed
the workshop method of
instruction, believing that
students learn best by doing.
Each department at the
time (radio broadcasting,
television, advertising, and
journalism) engaged students
in the actual activities of their
future professions. Because
this process "is at all times
meaningful, it encourages
greater and more sustained
interest and insures more
rapid progress," as well as
realistic career preparation.

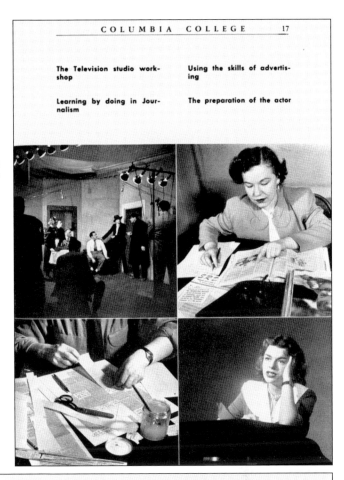

The Television studio workshop

Using the skills of advertising

Learning by doing in Journalism

The preparation of the actor

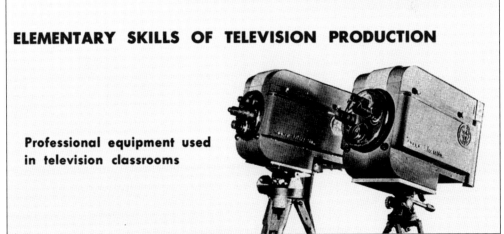

ELEMENTARY SKILLS OF TELEVISION PRODUCTION

Professional equipment used in television classrooms

CATALOG VIGNETTE, 1951. This catalog proclaims, "Television is a new frontier." Television first appeared in the curriculum in 1945, a year before the first major network was even licensed. Because television was a new and expanding field in which not many schools provided instruction, these offerings proved extremely popular. Often students would take jobs after a semester or two, leaving with only basic skills.

PUBLICITY, 1951. This four-page flyer emphasized the effective public speaking curriculum offered by Columbia. Learning to speak well was an advantage in the professional and business world, so college publicity stressed this coursework. Preparing for jobs in education, stage, film, journalism, or advertising required effective public speaking skills. Theory allowed students to fully understand the thinking behind the material and practice honed quality. Learning both theory and practice harkens back to the "learn by doing" classroom motto. Highlighting the power of voice, tenor, volume, and emotion also paid homage to the college's oratorical origins, yet illustrated the adaptability of this skill to new disciplines like radio and television.

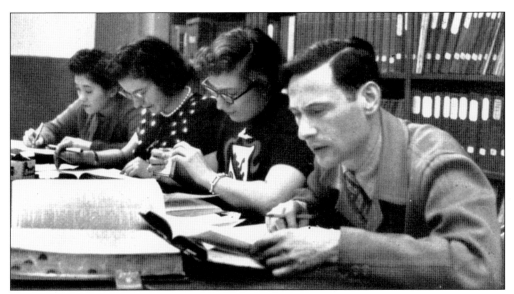

STUDYING IN THE LIBRARY, 1950. The college maintained a collection of 1,500 books by the time it combined with the Pestalozzi Froebel Teachers College. These collections were integrated and became property of PFTC, which took the bulk of the holdings when the colleges parted ways in 1963. Here are two different views of the library as it existed in the Fine Arts Building. Note the woman in the photograph above who is smoking, something unthinkable in the library today. The woman in the image below examines a record album. Libraries must collect materials that keep abreast of current information delivery mediums. Today the library no longer collects vinyl, but does house extensive collections of CDs and DVDs, in addition to providing access to online resources.

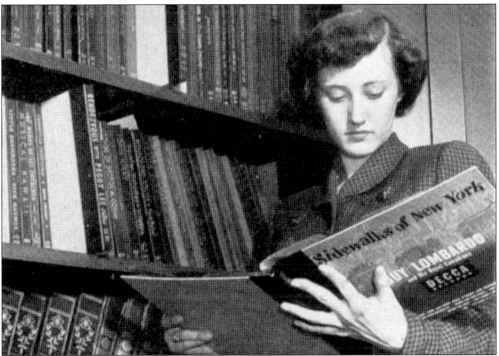

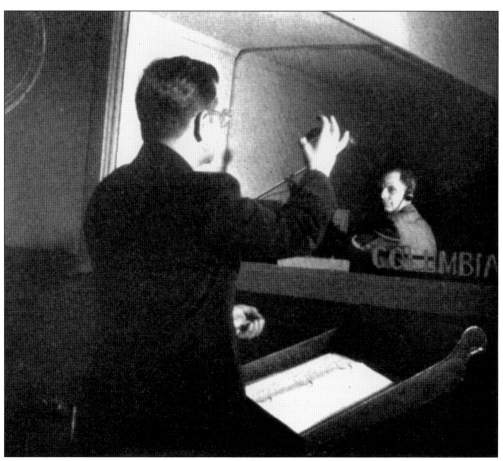

RADIO STUDIO, 1951. Students learn to communicate with the sound booth staff, as signals and exact timing had to be tightly coordinated in order to produce a show with no dead airtime. Columbia graduates were highly sought after for their broadcasting abilities and worked at every major television and radio station in the city by 1966.

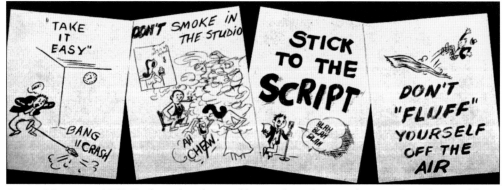

STUDIO MESSAGES, 1951. Each student learned how to broadcast under actual conditions. These professional "dos and don'ts" were posted in the radio studio as reminders for students. The signs enforced what was being taught in the radio classroom: speech and voice projection; microphone technique; use of the console, turntables, and controls; production and timing; sound effects; and the operation and care of studio equipment.

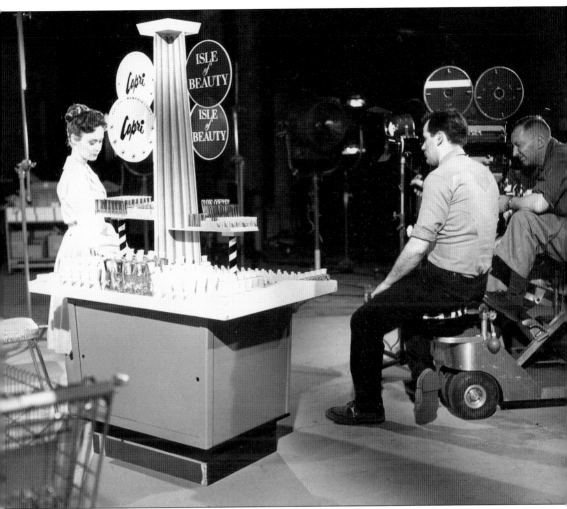

COLUMBIA COLLEGE LOS ANGELES, 1953. Acknowledging the concentration of television and related industries in Southern California, Norman Alexandroff opened a Los Angeles branch of Columbia that focused on these fields in late 1953. While visionary, this was a bold and unusual move to create a distant second campus united by a common administration, especially given Columbia's limited resources. Its faculty consisted of television professionals including Mike Kizzah (a leading sports producer), Melvin Wald (a television and film director), and Ludwig Donath (an actor and Oscar winner for *The Jolson Story* who had been blacklisted for his progressive sentiments). In 1959, the Los Angeles campus, now financially self-sufficient, separated from the Chicago institution and became its own private school. It remains in operation today under the name Columbia College Hollywood and continues to focus on film and television within a liberal arts curriculum.

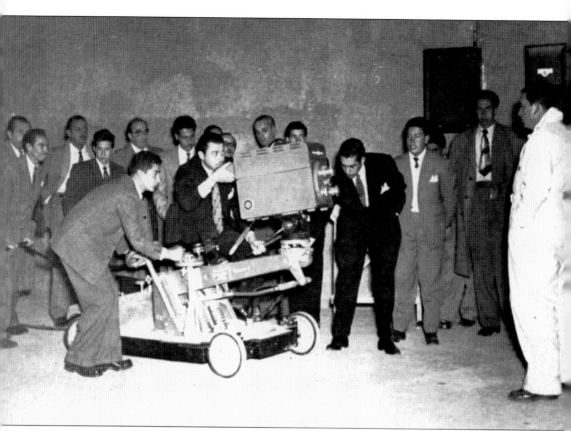

COLUMBIA COLLEGE PAN-AMERICANO, 1955. Columbia College Pan-Americano was established at the invitation of the Mexican and Latin American Association of Radio and Television Broadcasters. Mexican broadcasters wanted to expand their country's television operation and asked Columbia to organize and direct a training program in Mexico City. Its teachers were exclusively Mexican and were trained by Guillermo Camarena, who created Columbia's first television installation, and Roberto Kenny, manager of Televicentro's Channel 1. In 1957, it was determined that this branch could not be efficiently or profitably managed from either Chicago or Los Angeles, so the responsibility of the school was turned over to Camerena, Kenny, and Televicentro. Televicentro established an in-house training program, and eventually some of the curriculum was absorbed by the University of Mexico. Edward R. Murrow, director of the U.S. Information Agency, said that Columbia College Pan-Americano was an outstanding example of inter-American cooperation.

ADVERTISING ENGRAVING, 1951. Keeping abreast of the latest technologies and theories has always been important. In the 1950s, advertising students studied practical topics, such as letterpress, lithography, gravure, typography, photography, drawing, engraving, and electrotyping. In addition, theory classes like Business Psychology, Principles of Marketing, and Direct Mail Advertising Techniques rounded out their studies.

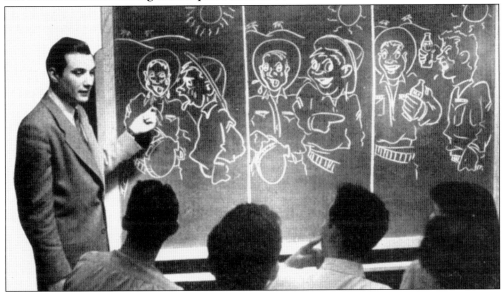

TELEVISION COMMERCIAL CLASS, 1951. There were several steps in the cycle of developing a television commercial. Students learned about selling an idea through this chalkboard depiction of an animated salesman. That idea was then developed, the commercial studio setup arranged, the camera rolled, and the product demonstrated, thus creating a commercial targeted to television-watching consumers.

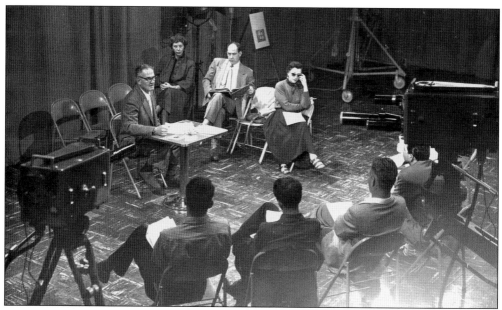

FIRST REHEARSAL, 1955. Students worked under professional conditions with the same equipment and facilities as found in professional television and film studios. Every aspect of production was studied, from first rehearsal of lines to completed work. Students learned audio, camera, and lighting skills, with directors and floor managers supervising actors and other crew. Acting and speech courses were popular for radio, television, and film work.

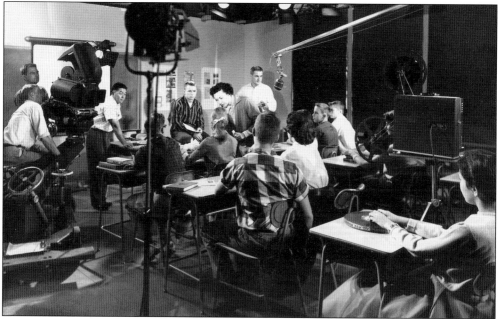

CAMERA SHOOT, 1957. With almost 2,000 television stations in the United States and the certain introduction of color television, this field expanded rapidly and offered an array of jobs in allied fields, such as advertising, art, and film. Columbia added full facilities for color telecasting so students could learn both black-and-white and color practices. Leading television directors, producers, actors, writers, and technicians served as faculty.

ADVERTISING, 1950s. Creating advertisements for print and broadcast involved creative input from many disciplines, including copywriting, advertising layout, production, design, market research, sales and promotion, set design, and acting. For television commercial work, learning to integrate camera angles, trick photography, slides, film, cartoons, and studio settings into commercials were also taught. Print work involved the study of letterpress, lithography, and gravure as well as typography, photography, drawing, engraving, and electrotyping. Production workshops brought together the various skills students acquired in other specialized courses. Columbia emphasized the "learn by doing" method as students created every part of an advertisement themselves and worked on every aspect of various advertising campaigns in consultation with working advertising professionals.

THEATER, 1950s. Even with all the technological advances of this time, Columbia did not abandon its past. Theater, a staple since Columbia's founding, offered students many opportunities to develop effective speaking and acting skills. The Columbia Players, an outgrowth of the theater workshop classes, received widespread local recognition. These workshops provided students with training in acting, and related theater arts, and the experience of staging dramatic, comedic, and musical productions before an audience. Coursework was provided within a framework of professional acting disciplines under the supervision of qualified professional faculty, and the audience-actor relationship was stressed. The acting coursework trained students not only for theater, but also for work on radio and television productions and included empathy, interaction, personality, projection, gesture, body movement, memorization, and other fundamentals of the discipline.

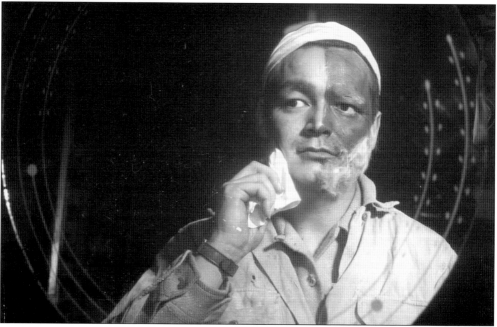

THE RELOCATION TO 207 SOUTH WABASH AVENUE. The former Chicago Business College building served as the college's home from 1953 until 1963. The move occurred because rent became too expensive in the Fine Arts Building. The schools occupied the second through seventh floors, with the library on the second and a television studio on the fifth floor. The Stevens Art Gallery Building (see page 14), to the left, appears to have had a new facade added. (Courtesy of *Chicago History in Postcards*, http://chicagopc.info/.)

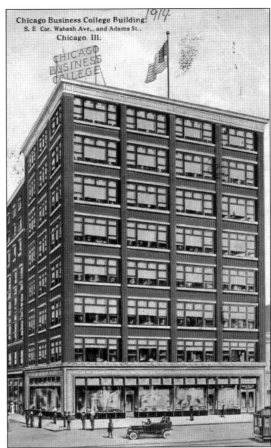

Chicago Business College Building.
S. E Cor. Wabash Ave., and Adams St.,
Chicago. Ill.

SOUTHEAST CORNER OF WABASH AVENUE AND ADAMS STREET, 2010. The Stevens Art Gallery Building was razed by 1949 and replaced for a time by a one-story taxpayer building, also later torn down. The building at 207 South Wabash Avenue was demolished in 1995 due to the Chicago Symphony Orchestra expansion. Rhapsody restaurant and a park now occupy the site. The college currently leases space at 218 South Wabash Avenue, visible across the elevated tracks.

COLLEGE AWARDS DEGREES TO NOTABLES

Piatigorsky, Waxman, TV Leaders Honored

In an impressive ceremony, Columbia College awarded honorary degrees to eight outstanding contributors to the Communication and Entertainment Arts and Sciences.

At the head of those honored, was Gregor Piatigorsky, the world renowned cellist, who received the Degree of Doctor of Letters and Humanities. This thrilling artist, who has made such a singular contribution to the culture of all peoples, was among the first of the world's great musicians to perform for television audiences, appearing on the BBC during the TV's experimental infancy.

Awarded the Degree of Doctor of Science was Mexico's Guillermo Gonzoles Camarena, Eng. Camarena, a pioneer scientist in the field of television, is credited with the invention of the sequential color TV system.

The Degree of Doctor of Letters and Humanities was awarded to Dr. Franz Waxman, Founder-Director of the Los Angeles Music Festival and Oscar winning composer of the musical scores of many of the top motion pictures, "Place in the Sun" and "Sunset Boulevard", and musical director of Columbia Pictures.

In honoring the leaders of the Television industry, the President of Columbia College, Norman Alexandroff, said, ". . . . Television does not create a culture, it communicates what exists. TV's wonderful accomplishment is that it has already communicated so much of the finest in man's cultural achieve-

(Continued on page 3)

columbia college • 68th Year

Alumni DIAL

Chicago, Illinois

1957 CLASS PLAYS LEAD IN SPECTACULAR SUCCESS STORY

SIXTY-FIVE ALUMNI — NOW HAVE BUSINESS ADDRESS IN TV—RADIO—FILMS—ACTING—ADVERTISING

With the final returns not yet tallied, 1957 shapes up as the greatest year yet for Columbia College Graduate Placement.

"LEARN-EARN" PROGRAM KEEPS A FOOT IN DOOR

The roll-call of current students combining work in their career fields with their Columbia College programs reads like a "where's-where" of the top outfits in TV, Radio, Film, and Advertising.

The approach was developed to:

Give students actual, on-the-job experience in their main, or closely related, fields of interest, and to assist them in attending College with greater financial security.

Featured in a partial listing are:

Fred Wroblewski, Film Director, Chicago Film Co.; **Clyde Ruppert**, Director of Producer's Services, Coburn

(Continued on page 4)

In what the nationally syndicated columnist, Irv Kupcinet, called "a real Horatio Alger story", **Jack Wartlieb's** new, top billing as WBBM-TV's (CBS) Production Manager, set a speedy pace for the class. Jack, who began his sparkling career in WBBM-TV's mailroom during his first year at Columbia College, made the heights at twenty-seven, just a few months after his college graduation.

Ken Caparros, puts his degree in a frame with new Columbia Records recording contract, and is off on a nationwide whirl to promote his newest record release. **Peter Klein**, Film supervisor at WBBM-TV moves to KMOX-TV (CBS), St. Louis, as Director of Film Operations.

More on the dial: New Asst. Production Manager, WBBM-TV, CBS is **Fraser Head**, who moves over from WNBQ-TV (NBC). **Bernard Miller**, Newscaster-Announcer, WISC-TV, Madison, Wisconsin. **Don Prescott**, Cameraman, WTVO-TV, Rockford, Illinois; **Howard Van Antwerp**, Sarra Films; **Fred Speer**, Announcer, WKBZ, Muskegon, Michigan; **Garna Pulliam**, "The Marty Faye Show", ABC-TV; **Trudie Campbell**, "Women's Editor, K. V. A. S., Astoria, Oregon; **Mike Rosen**, Account Executive, Ron Terry Productions; **Margaret Warren**, WNBQ-TV (NBC). **James Sheeran**, Asst. Advertising Manager, Helene Curtis, Inc.; **Albert Scheer**, WYES-TV, New Orleans; **Nick Spasojevich**, Prog. Manager, KFAD, Fairfield, Iowa. **John Holm**, KBHS, Hot Springs, Arkansas. **Robert Kasparian**, Actor; **William King**, WNDU-TV, South Bend, Indiana. **Ted Kennedy**, WHAS-TV, Hastings, Nebraska; **Betsy Kraft**, WNBQ-TV.

Len Kay, Time Buyer, McCann Erickson Advertising Agency (Chicago); **Martin Holtman**, Announcer-

(Continued on page 3)

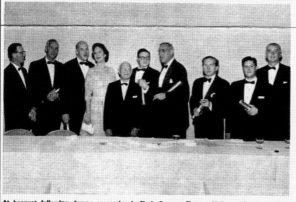

At banquet following degree processional; Clark George, Thomas McCray, Alberta Hackett, Columbia College President, Norman Alexandroff, Selig Seligman, Gregor Piatigorsky, Franz Waxman, Guillermo Cmarena, Richard E. Moore.

COLUMBIA DIAL, **1958.** Serving as both the campus newspaper and the alumni publication, the *Dial* announced news about the college to a wide audience. This particular four-page issue reported on honorary degrees conferred, alumni news, curricular news, student news, and events. Lillian Hellman's drama *The Little Foxes* was performed by students on stage as well as Sean O'Casey's *Plough and the Stars*. Columbia classes on folk music and film production and visual aid materials were also highlighted. The *Columbia Dial* was produced during the 1950s. There were no college publications during the early years of the 1960s, but in 1964, the *Columbia College Newsletter* emerged. In 1973, the college split the audiences and two publications were produced: *Alumni News* and the student newspaper *CC Writer*.

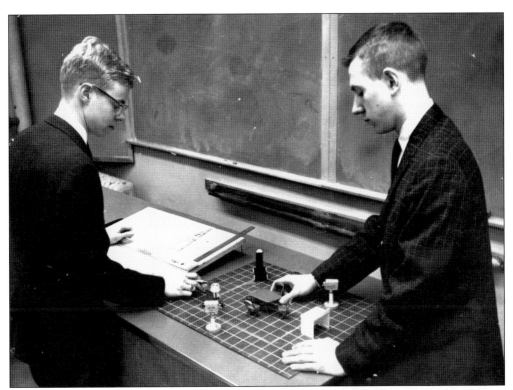

TELEVISION CLASS, 1960. This staged photograph was taken in faculty member Thaine Lyman's television production workshop class. Students were asked to act like they were planning a television shoot. While students did not generally wear suits to class, jeans were never worn. On the day this photograph was taken, students were told that the college was going to shoot publicity pictures and to dress accordingly.

ADVERTISING, C. 1960. Communication arts was a complex intertwinement of several disciplines, including radio, television, film, advertising, journalism, and writing. While the college curriculum had emphasized cross-disciplinary training earlier, the move toward studying across many fields really took hold during this decade. Now programs such as advertising could be studied in conjunction with coursework from other areas of communication offered by the college.

In recognition of the remarkable growth of

CAREER OPPORTUNITIES

IN THE FIELDS OF COMMUNICATION

A Specialized College Education Can Give You a Head Start on Career-Success in

TELEVISION
RADIO BROADCASTING
DRAMATIC ARTS
MOTION PICTURES
ADVERTISING
JOURNALISM

As a major field of study in the communication arts within a college degree program • or specialized study in separate fields of interest • degree programs in teacher training for Speech Education majors.

THIS IS COLUMBIA COLLEGE'S 70th YEAR OF COLLEGE SPECIALIZATION IN THE COMMUNICATION-ARTS

Write for information.

COLUMBIA COLLEGE

Founded 1890
207 South Wabash Avenue, Chicago
WAbash 2-6762

FLYER, 1960. This flyer focused on the communication arts curriculum offered by the college. Columbia was among the earliest schools to combine the major fields of communication under one common rubric known as "communication arts." The interdisciplinary curriculum gave students the opportunity to study diverse coursework in related fields of study. Subjects covered a wide range of topics, from the creation and presentation of audiovisual materials to an introduction to the art of puppetry to business problems in the film and music industries. The workshop method of instruction was an effective mode of teaching based on the notion that students learn best through practice. In conjunction with a thorough grounding in general education courses, the communication arts curriculum allowed students to pursue studies in communications or concentrate in specialty subject areas. At the time, these included speech, education, television, radio, motion pictures, the stage, advertising, and writing.

Three

FUSION OF
THEORY AND PRACTICE

LOGO, 1964. Completely independent for the first time in nearly four decades, the college sought to reinvent itself. The new logo, an outgrowth of an image used throughout the 1950s (see opposite page), depicted the globe and a radio wave nested within the college's initials. Subsequently replaced several times, this logo was later incorporated as part of the official seal (see page 124).

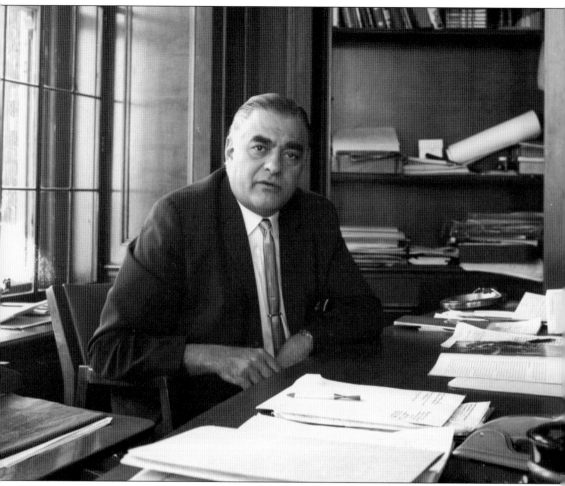

MIRRON "MIKE" ALEXANDROFF (1923–2001). Born in Chicago in 1923 to educators Norman and Cherrie (Phillips) Alexandroff (see page 37), Mirron Alexandroff earned a bachelor of arts degree in 1947 from Roosevelt University and a master of arts degree in 1948 from Columbia College. From 1942 until 1945, he served as a sergeant in the U.S. Army in the South Pacific, and upon discharge, he took a position as psychologist in Columbia's Psychological Guidance Center, an independent agency for the Veterans Administration, later becoming its manager. After his father died in 1960, he became president of the college in 1961, taking over at a time when the college was struggling and enrollment was low. He utilized Chicago-area media professionals as instructors, geared curriculum more firmly toward the arts and media, pushed for higher minority enrollments, and made higher education accessible to all, with policies such as noncompetitive admissions. With this new vision, the college grew from less than 200 students to more than 7,000 during his tenure and physically grew from a one-floor school to one of the largest South Loop landowners.

THE RELOCATION TO 540 NORTH LAKE SHORE DRIVE. This was the college's home from 1963 until 1977. Without the Pestalozzi Froebel Teachers College, the college could no longer afford the rent at 207 South Wabash Avenue and needed to relocate. Wishing to remain an urban, vertical "sidewalk college," a conscious decision was made to stay in downtown Chicago. Board member Bud Perlman owned this building and made it available to the college, as well as advancing funds for remodeling. The building is across the street from Navy Pier, then the home of the University of Illinois at Chicago. The college initially occupied the seventh floor, but eventually expanded to other spaces as they became available. As its prosperity grew at this location, space became a premium, as the photograph below illustrates, with students studying in a hallway. Today the building houses condominiums.

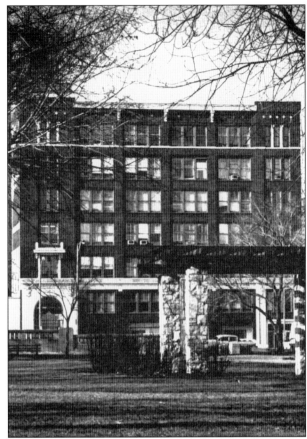

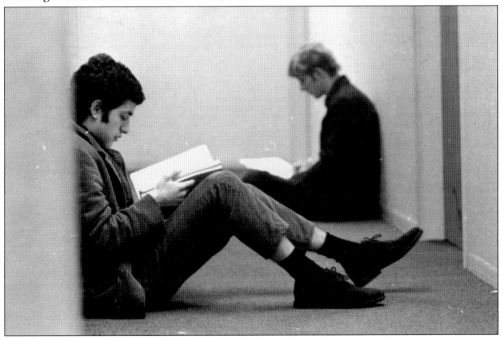

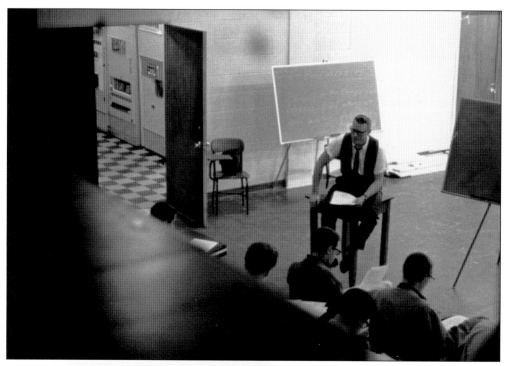

STUDIO CLASSROOM, C. 1960s. The 540 North Lake Shore Drive building allowed for more studio space. A studio for theater and television was located along the west side, with a control room at one end and five rows of theater seats with drop tables at the other for classroom use. The new space also had a closed-circuit television system for both internal and external viewing.

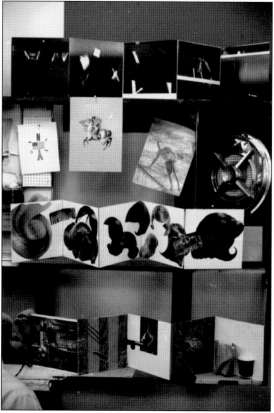

DISPLAY, C. 1960s. The building had space for small display items or production documents, such as those pictured here. This work illustrates process, design, style, and found objects—areas of study that are still of import to the college. Artwork from the Columbia community continues to hold an important place in the college.

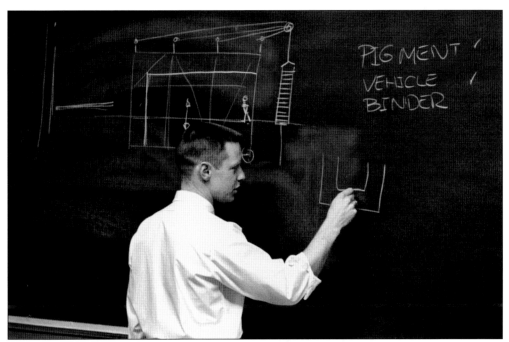

TRADITIONAL CLASSROOMS, C. 1960s. The seventh floor at 540 North Lake Shore Drive held space for classrooms. Five good-size rooms suited this purpose. There was also space for a small library, a photography darkroom, a radio studio, and an office for the president of the college. Subjects studied within these rooms included English language, literature, poetry, journalism, science, social science, education, and humanities courses.

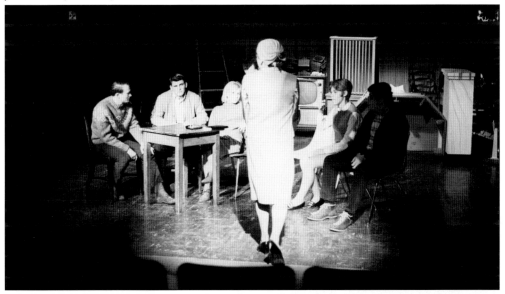

THEATER, C. 1960s. A combination studio and stage, this space held more room for productions and theater instruction. The storage room, containing props, scenery, and other gear, also doubled as a dressing room for stage productions. The dramatic arts program was geared toward students interested in professional acting or directing through study of speech and related theater arts.

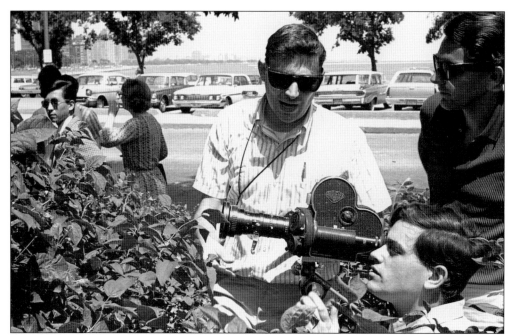

OUTDOOR SHOOT, c. 1960s. After the split with the Pestalozzi Froebel Teachers College, Columbia refocused. Articulating the mission and purpose of the school moved the college in a new direction, that of creating a comprehensive college of media and fine arts while still adhering to theory, practice, and to learn by doing in whatever form. Filming assignments took students outside, making city-as-campus more than just a concept.

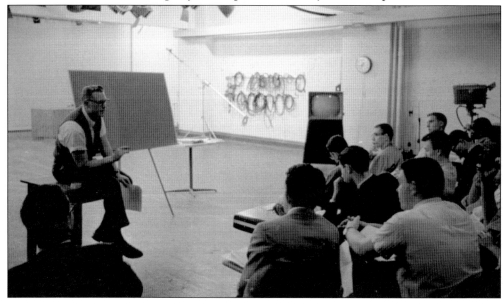

INDOOR STUDIO, c. 1960s. The newly defined mission of the college also ensured that studios were equipped with the professional items students needed to learn how to use. Wires needed to be coiled and put away, and classes needed lecture space and room to stage productions. Faculty, both full time and adjunct, were industry professionals, teaching students the craft, a practice to which the college still adheres.

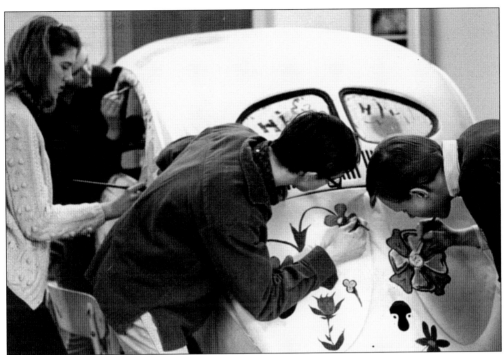

TRADITIONAL AND NONTRADITIONAL STUDY SPACE, 1965. There was room for creativity in the classroom. College subjects frequently were made relevant to the specific careers of Columbia students. The students pictured above found the shell of a car on the streets outside the school and were encouraged by faculty to give it new life. Yet there was room for the more conventional study and research space for students to explore and learn. Columbia was home to the traditional and the ground-breaking, theory and practice, and research and fun, with its faculty, primarily adjunct working professionals in the field, embracing the duality of the college's new mission. Columbia was experimental, yet disciplined and innovative, but professional, much like the mission of the college today.

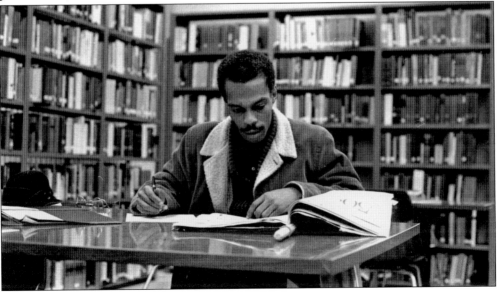

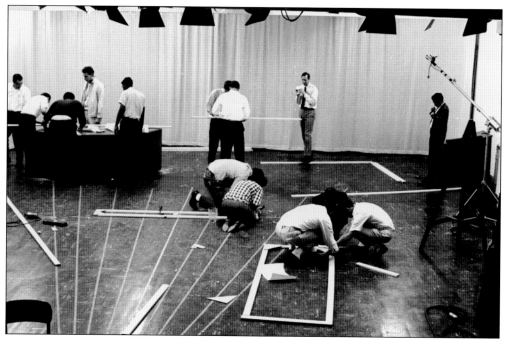

SET DESIGN, 1965. When the college refined its mission, the elements that aligned well with the new direction remained. The workshop method of teaching, that is, the holistic approach to learning all functions within a discipline, fit well into the new curriculum. Dramatic arts is one such example. Students received intensive training in acting, speech, and related theater arts subjects, including design skills such as creating scenery and building sets. Regular stage productions of significant plays, including ones by local writers like Studs Terkel, were produced. Television and motion picture productions were also created, thus giving those interested in acting the opportunity to experience all acting mediums.

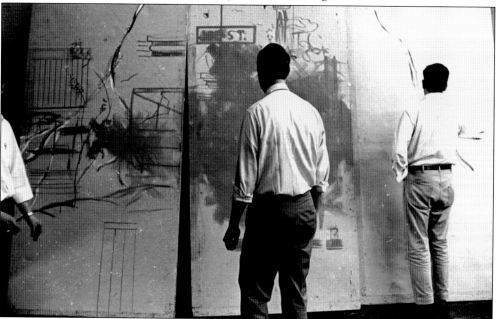

THEATER PERFORMANCES, 1965. Whether a modern or classic production, theater at Columbia was a group effort. From set design to directing, lighting to sound, and acting to singing, the work was completed as a group. The college also implemented a new course sequence, visual communication, which augmented the concept of communication arts already in place. This new sequence challenged students to investigate form, space, color, motion, and texture to discover and understand the visual environment. Coursework included photography, lighting, scene design, and basic visual communication classes.

This new perspective added dimension to communication arts education. Performances were cutting edge, including complex set designs, modern plays, and dramas that explored sensitive social issues.

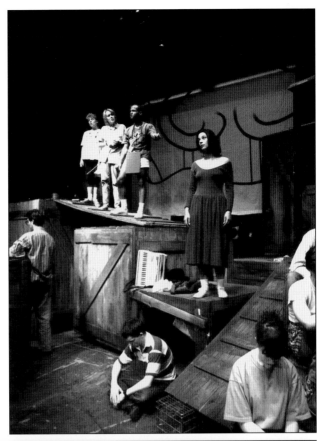

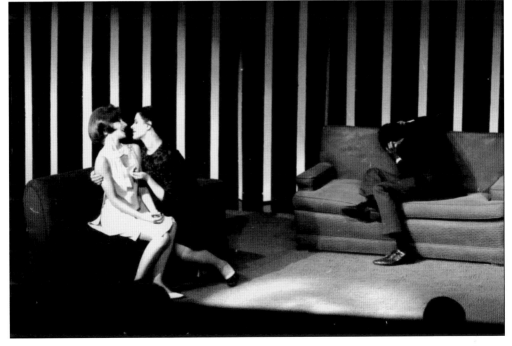

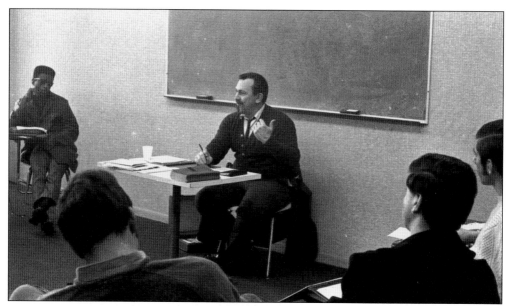

TRADITIONAL CLASSROOM, c. 1968. In addition to studio space, there remained a need for traditional classrooms. Classes in theory, history, humanities, science, and contemporary social studies were offered. A new program in mass communications for foreign students was also introduced. Designed to educate students returning to their own countries, this was a yearlong program organized to provide intensive education in television, radio, film, journalism, and audiovisual materials.

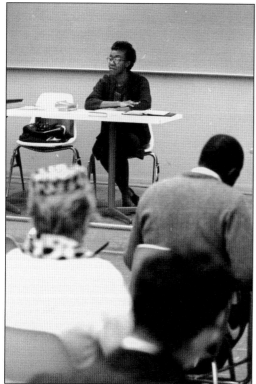

GWENDOLYN BROOKS, 1964. Pulitzer Prize–winning poet and Illinois Poet Laureate Gwendolyn Brooks taught at Columbia College from 1963 until 1969 and received the first-annual honorary doctorate awarded by the college, a practice that continues today. Other honorary degrees had been given sporadically: In 1957, honorary doctorates were conferred on eight recipients, and in 1938, an honorary master's degree was awarded to Jimmy Durante.

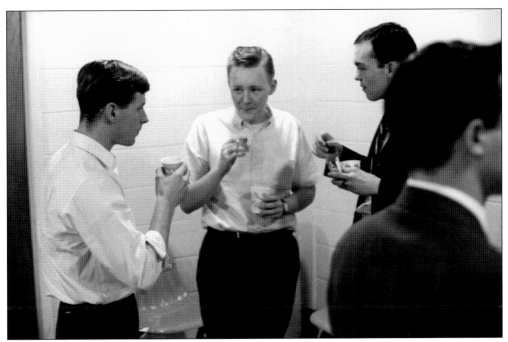

SOCIAL SPACE, C. 1966. Columbia was a commuter school, as there were no dormitories at this time and few options for living near campus. Students socialized when possible between classes, on the set, or in lounge space. There were also activities in which students could become involved, such as the college newspaper, the design and display of student work, music and theater programs, campus chapters of professional organizations, and student meetings with working professionals in their field. In a college with the city of Chicago as its campus, there were plenty of chances for students to eat, embrace, converse, work, smoke, practice, and socialize together.

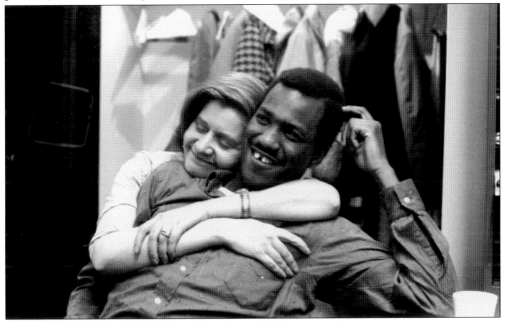

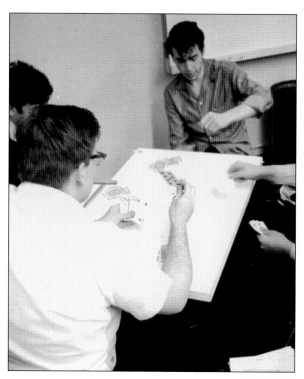

SOCIAL SPACE, C. 1965. Creative ways of playing cards and taking breaks on the set allowed students to sit and relax whenever time permitted. Opportunities to socialize allowed students to learn from each other, collaborate on projects, think creatively, and make friends, despite the lack of a formal student center space. Nearby restaurants also served as convenient places for students to meet and eat. Faculty, staff, and students also mingled at parties in private homes. In the days before e-mail, text messaging, and other online communication methods, faculty and staff home addresses and phone numbers were printed in departmental brochures.

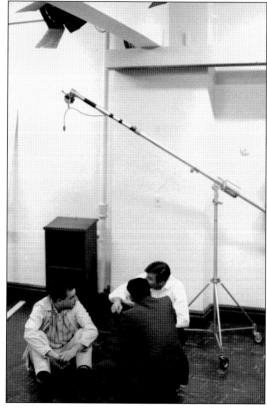

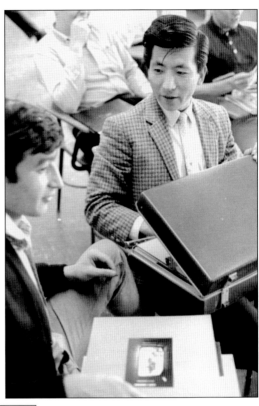

CAMPUS STYLE, 1960s AND 1970s. Accessories, clothing, and hairstyles at Columbia have always been quirky and unique. During the early 1960s, dress pants were worn, hair was cut short, and clothes were tailored. By the early 1970s, jeans were the norm, long hair was the convention on both men and women, and clothing was loose and relaxed. Even the mode by which books and other items were carried to campus changed: In the 1960s, students lugged around heavy, hard-shelled briefcases; by the 1970s, students wore lighter, fabric backpacks. Eyewear also underwent change. In the 1960s, students sported heavy plastic frames; the 1970s ushered in round wire frames, such as the ones pictured below.

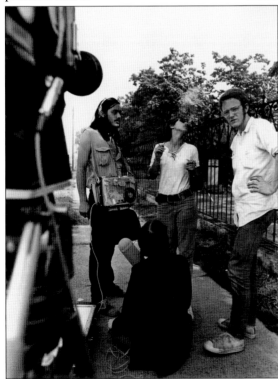

SMOKING, 1960s. Columbia students and faculty regularly smoked during class. Smoking in public places was the norm, and ashtrays were found on worktables, in lounge areas, and even on the library's checkout desk (see the above image on the opposite page). Pictured here are scenes of typical Columbia classrooms. Photographs from this era also show students and faculty smoking pipes and cigars. In 1990, the Illinois Clean Indoor Air Act was passed, banning smoking in public buildings. It was replaced in 2007 by the Smoke Free Illinois Act, forbidding smoking in the buildings and spaces outlined by the previous act and also in restaurants and bars and within 15 feet of entrances to public buildings.

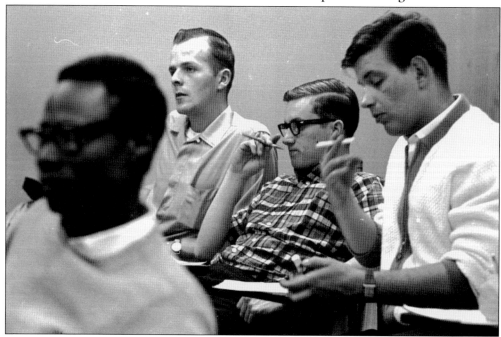

LIBRARY, *c.* LATE 1960s. The split with the Pestalozzi Froebel Teachers College in 1963 left Columbia without a library collection, viewed as a stumbling block in the ongoing the quest for accreditation. Building collections became a primary focus during this time, and much money, both from operating expenses and fund-raising efforts, was spent rebuilding the collection. Note the ashtray on the circulation desk.

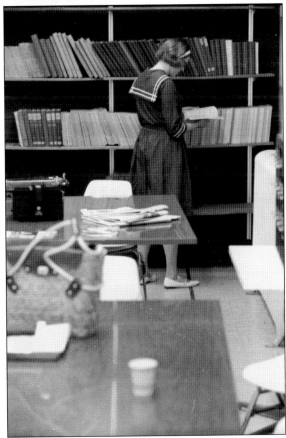

LIBRARY, 1967. Space for the new library, including a reading room and a circulating collection, was created at 540 South Lake Shore Drive in 1967, and a new librarian was hired to build the collections. Holdings grew to 10,000 volumes in 1967 and doubled to 20,000 volumes by 1968. In 1982, the Central YMCA Community College closed, and Columbia purchased this collection outright, integrating it into its main collection.

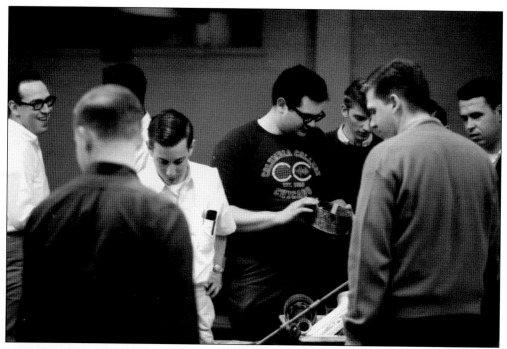

Logo T-Shirt, *c.* Mid-1960s.
The student in the center of this photograph is wearing a T-shirt with the college logo. By the mid-1980s, the college's bookstore was selling Columbia-related merchandise, such as shirts, jerseys, and class rings. Swag still plays a large part in the marketing of the school, with all manner of items sold and given away throughout the year.

Catalog, 1966–1967. This catalog outlines the curricular changes implemented in 1964 as the college moved toward offering arts-related majors within a liberal education. While general education requirements were already part of the students' education, the percentage of these classes necessary to complete a bachelor's degree went from about a fifth of the course load to nearly half. The number of general education offerings was also broadened.

STUDYING, 1967. Artwork on campus was displayed wherever possible, tucked into every nook and cranny. Students in the popular art history class, working with paper, paint, clay, and structural materials, immersed themselves in the history of art by recreating it. The notion of "learn to do by doing" was apparent in this course, as theory and practice were integrated to fully experience art.

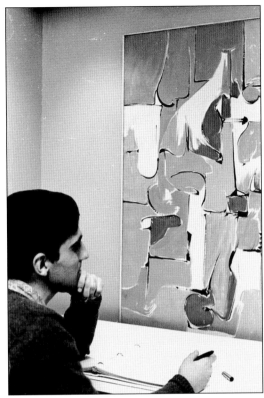

STAIRWELL CONVERSATION, 1967. Success came swiftly with the college's new focus, and enrollment began to swell. Space remained at a premium, however, even after the school rented additional room at 540 South Lake Shore Drive and expanded into 469 East Ohio Street as well. Here the realities of a large student body and a vertical campus come into play.

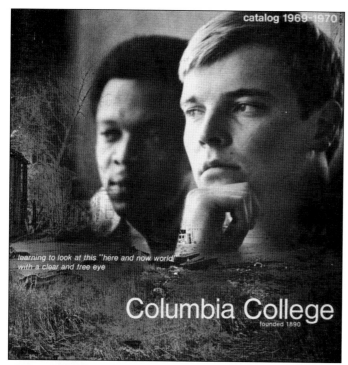

CATALOG, 1969–1970. This image graced the school's catalogs from 1969 until 1972, a time of social upheaval and emerging self-expression. Believing the notion of the well-educated man, bound by majors and minors and fixed curricula, repressed individual student options and forced learning pathways, the school rejected this model. Although general education and special concentrations remained, students were encouraged to pursue study in accordance with their particular interests and talents.

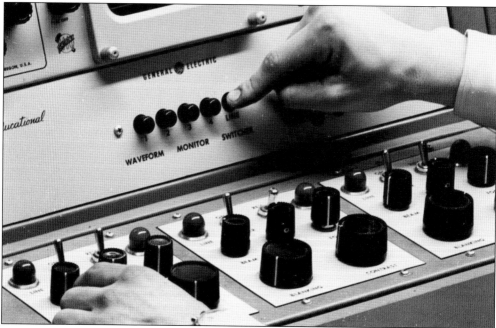

EQUIPMENT, 1969. While general education coursework was being added to the curriculum, mass communication programs like film, television, radio, public information, journalism, dramatic arts, photography, and advertising remained at the core of study. The college educated creative students in a craft and based this education on a foundation of humanities and contemporary issues in order to beget graduates who were well informed in public arts and issues.

Violence
Blood
Thunder
Mayhem
Sadism
Murder

"...sit down in front of your television set...stay there...keep your eyes glued to that set...you will observe a vast wasteland."*

**Newton Minow, Chairman, Federal Communications Commission May 1961*

That was six years ago. In our opinion, nothing has changed. We are still assaulted by "... game shows, audience participation shows, formula comedies about totally unbelievable families ... Western badmen, Western good men, private eyes, gangsters, violence, more violence, and cartoons."*

If you are appalled by American television, if you refuse to accept the excuse of "circumstances beyond our control", contact Columbia College of Chicago. We're doing something about it.

Columbia College teaches the creative arts with emphasis on television, radio, and communications. The faculty is composed of people like Gwendolyn Brooks, winner of the Pulitzer Prize for poetry; Harry Mark Petrakis, prize-winning author of "A Dream of Kings"; William Braden, winner of the Field Award for distinguished journalism; Father James

Jones, renowned pastor; Artists-in-Residence, Composer William Russo and Sculptor Harry Bouras.

These people, and others like them on the Columbia faculty, are not just thinkers. They are achievers in their own fields, who can communicate to their students the kind of contemporary message and human understanding which hopefully will reshape our cultural environment.

If anybody can transform television from its present sorry state into something constructive and illuminating, the Columbia graduates can. But we need money for technical facilities. Money for more of the kind of faculty we already have. Money for scholarships. Money for a new building, or even an improved building.

Write us for more information about Columbia College. We'll send you information. We'll come in person to talk to you. We need your help.

Columbia College(Chicago)Founded1890
540 North Lake Shore Drive, Chicago, Ill. 60611 • Phone 467-0300 • Mirron Alexandroff, President • *(Dedicated to a complete college education, focusing on the creative arts)*

ADVERTISEMENT, 1967. Columbia ran this full-page advertisement in the December 1, 1967, issue of *Time* magazine. The cover featured clothing designer Rudi Gernreich, and the issue contained articles about the economy, the Vietnam conflict, Cambodia, the Middle East, Ted Kennedy, inner-city issues, and television. One particular article, *Mortars at Martini Time*, focused on watching the war on television news during the cocktail hour. Television show offerings during this week were holiday-based and included Bob Hope, Perry Como, Dean Martin, Tennessee Ernie Ford, and Merv Griffin. Other television programs featured newscasts, sports, detective shows, soap operas, situation comedies, and teleplays. This advertisement, nestled within the pages and designed to be noticed, focused solely on bringing substance to the mass communication media through a high-quality Columbia education. The catalog this year stated, "The dynamic growth of the media and arts of mass communication represent the one development of the twentieth century likely to leave the sharpest impression on modern society." Columbia continues to meet the challenge of communication through vital education.

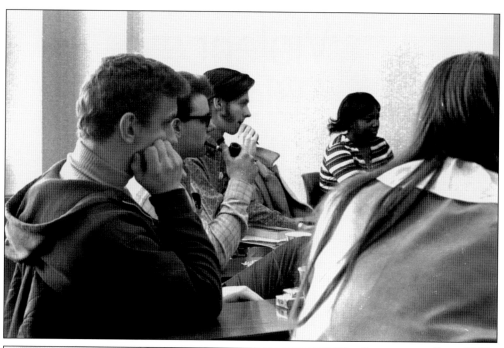

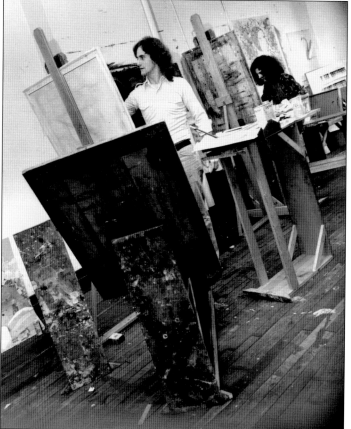

STUDENTS, C. LATE 1960s AND 1973. Lecture and art classrooms in the 1960s and 1970s held much less technology than today, with chalkboards, slide carousels, and overhead projectors instead of computers, flash drives, and Internet connections. One constant, of course, is that classrooms contain students. Students today do not differ much from the generations of students who passed before them, with exception to their style of dress, hair, sideburn length, gadgetry, and indoor pipe smoking. But in the ways that really matter, Columbia students then and now remain passionate about and dedicated to their craft and to their education.

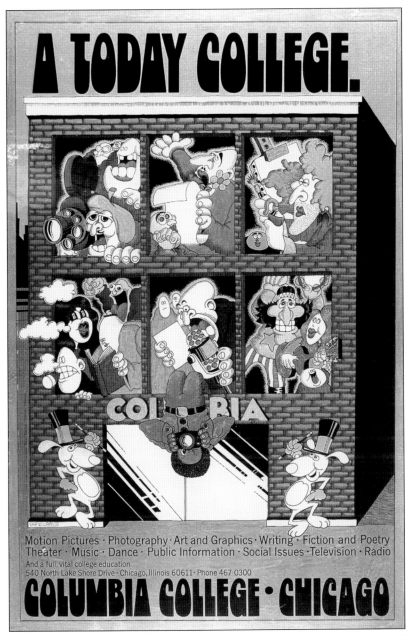

POSTER, 1972. At this time, the college offered a program in art and graphics with a focus on social issues and public art. This poster, created by William Biderbost and illustrated by Skip Williamson, reflects coursework that is still present in the curriculum today. Biderbost was a poster designer and a Columbia adjunct faculty member teaching fantasy drawing and poster design during this academic year. Williamson was a political cartoonist involved in the underground comix movement. His poster illustration represents an interpretation of the 540 North Lake Shore Drive building, and according to Biderbost, "The illustrations were meant to convey a feeling of freedom and free experimentation in the arts." These sentiments are still very much present at the college today. Columbia students continue to experiment in the arts and benefit from the freedom of expression found at the college.

GROUP DARKROOM, FALL 1973. Columbia courses focused on teaching technical competency while stimulating students to aspire to high levels of artistic and humanistic involvement. Photography coursework began in 1965, and it became its own department in 1969, with facilities that included both group and individual darkrooms. Today the Department of Photography still supports a wide range of innovative and ambitious photography, both film based and digital.

GALLERY SPACE, 1971. Gallery space was limited to available wall space at the 540 North Lake Shore Drive building. The stack of boxes pictured is part of the "Project" series, a portfolio of photographs taken by college faculty and students that are available for purchase annually. Now the college is home to the Museum of Contemporary Photography and many galleries featuring artwork and performance art.

BULLETIN BOARD, 1973. Even though Columbia was primarily a commuter school, there were numerous events and programs for students. Exhibits, stage performances, film programs, lectures, and campus chapters of professional organizations were all announced via the medium of the time—the bulletin board. The one pictured here announces a series of performances from the Free Theater, developed by the Columbia College Center for New Music. The Free Theater performances, held off campus at 3257 North Sheffield Avenue and at the Performing Arts Center at 1725 North Wells Street, were at the heart of Chicago's vital music, theater, and dance community. These performances, over a five-year period, had an annual attendance of more than 25,000 people. Columbia's theater, music, and dance centers were all located in the near north side and Lakeview areas. Adjacent wall space by the bulletin board was dedicated to information about those who were awarded honorary degrees from the college.

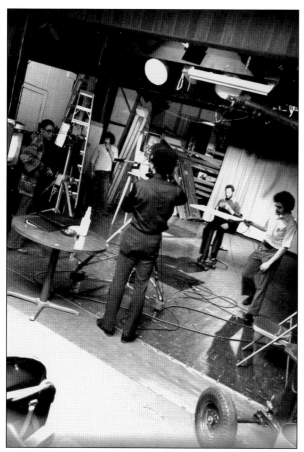

STUDIO SPACE, 1973. New coursework was being developed in contemporary studies, such as comparative religion, human relations training, nonviolence studies, black studies, the urban crisis, the self and society, the artist as organizer, and Chinese culture. Such classes augmented the professional education programs the college offered in television, film, theater, and mass communication arts and reflected the growing need for understanding the issues that students faced when they left campus. Contemporary social issues were an important way for students to engage in their world. With its sharp focus on offering students professional coursework alongside a strong foundation in liberal education, the college had applied for accreditation. It was also engaged in completing a self-study and hosting the Commission on Education examiners who would write a recommendation based on their visit to the campus.

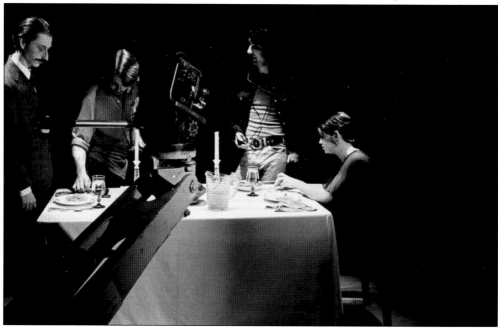

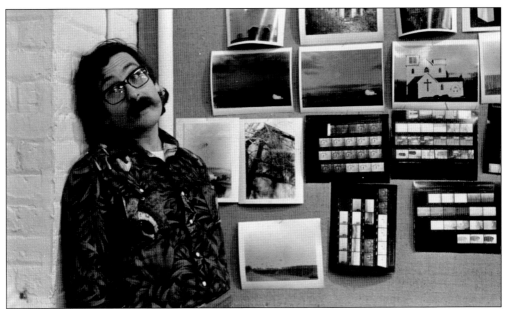

PHOTOGRAPHY AND FILM, *c.* **1974.** Columbia now offered a liberal education in the creative and public arts with mass communication programs at its core. Columbia resisted curricular restrictions by encouraging students to take classes from all the course and program offerings. General education and special concentration courses were mandatory, with 48 semester hours compulsory, but the rest of the bachelor of arts degree requirements were based on a particular student's interests. Known as the "whole college process," this new direction allowed a great degree of personal exploration for students in any area of interest that they wished to study. Courses in experimental film, directing, advance film study, film criticism, film sound and editing, photography (basic and advanced fundamentals), editorial photography, and the aesthetic history of photography were all open for students with the desire to learn.

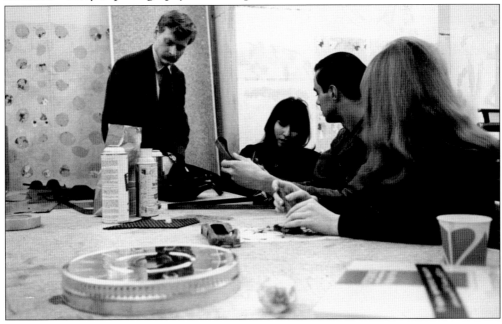

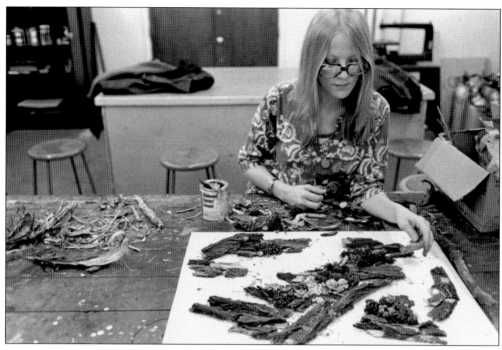

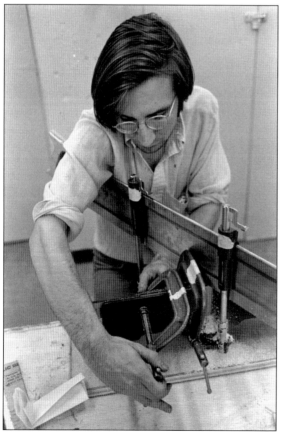

ART AND DESIGN, c. 1970s. The fine arts did not play much of a role in the college's curriculum prior to the introduction of the graphics and public art program in 1970. The college believed that traditional professional arts had become expensive, inaccessible, and irrelevant to a mass audience and that art itself needed to evolve in order to have a significant audience and social effect. The new program sought to redesign art's form and content and address new themes. Additionally, it had the stated goal of exploring alternatives to the customary professional occupations of artists and to involve students in this experience. The initial offering of 16 different classes has expanded to the vibrant art and design program now available, with more than 200 different course offerings listed in the 2009–2010 catalog.

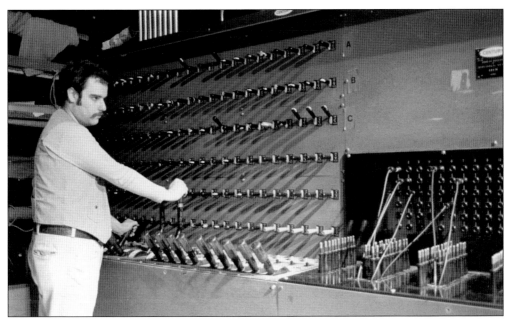

STAGE PRODUCTIONS, c. 1970s. A donation from WBBM-TV, a local Chicago station, this lighting board offered students the opportunity to test out the theory they learned in the classroom. Coursework in technical theater, play production and public performance, acting, voice, speech, dance, movement, and theater management gave a comprehensive overview of the business of theater. The college also offered coursework called The Chicago Project. Providing students the opportunity to perform and tour around the Chicago area, nationwide, and internationally, the class focused on producing a complete work from creating, performing, designing, and collaboratively working out ideas or problems that arose during stage productions.

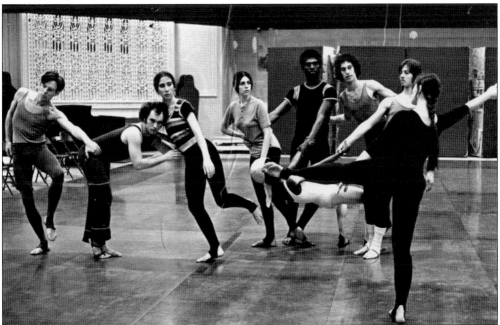

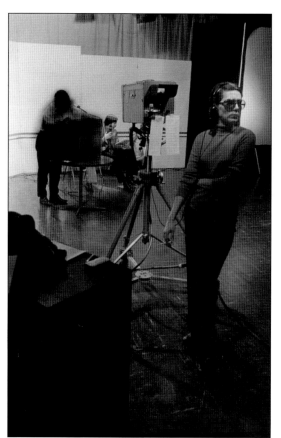

TELEVISION STUDIO, C. 1974.
Coursework in television included a television production workshop where students created live studio programs using full television facilities and integrated film and videotape materials into the broadcast. All facets of television technique came into play: sound, lighting, acting, filming, timing, and directing. Putting theory into practice, this program demanded a high degree of coordination and collaboration among participants.

FRITZIE AND PHYLLIS, **1974.** Born out of the college's early roots of voice culture and dramatic action, then honed in the radio broadcasting world, theater has always been part of Columbia's curriculum. Evolving from individual classes into a workshop program and finally its own concentration in 1959, the dramatic arts program was born. From 1970 until 1997, the theater arts program partnered with the music program to form the Department of Theater/Music.

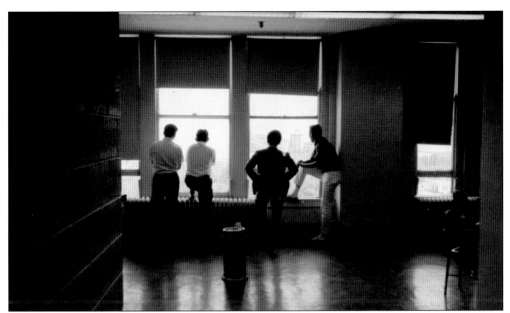

TAKING BREAKS, C. 1970. One major advantage 540 North Lake Shore Drive offered over 207 South Wabash Avenue was a much more tranquil campus. The Wabash building sat adjacent to the elevated tracks, and the rumbling of trains was a daily fact of life. This must have been especially disruptive to those studying in the second-floor library. By contrast, the Lake Shore building afforded views of Lake Michigan (above) and sat opposite two parks (below). The campus today is a mixture of both environments, with many properties abutting elevated tracks and others fronting Grant Park. Since 2000, the college has been converting lake-facing spaces into common areas, as they become available, to be enjoyed by all. In addition, in 1990, the college converted a parking lot at Eleventh Street and Wabash Avenue into a sculpture garden.

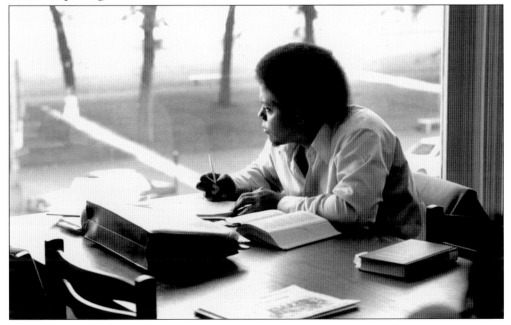

CC WRITER

VOL.I NO.I COLUMBIA COLLEGE NOVEMBER 1973

Closing the Accreditation Gap

Columbia has always tried to face others looking at us. We have found there are no outsiders because we are not a closed stuffy institution or a shut off community.

November 26, 27th, and 28th there will be seven of those non-outsiders taking a look at Columbia. They will be looking hard, observing classes, talking with students, teachers, administrators, and alumni, seeing what students achieve here.

Their's is not idle wandering. Looking hard is their job as observers for the North Central Organization, who will decide if the present school is living up to its original spirit and if Columbia meets the standard of adequacy and excellence.

"The process of accreditation is a well established process to see that a school serves the needs of the students and the community," says Randall Thompson of the volunteer accrediting organization. "We will be talking with everyone we can, including community people. We will review what we see with what

Dean of academic credits Lou Silverstein points out, "it is not a problem of the transfer of academic credits from Columbia pushing our accreditation. Several of our students have gone on to graduate schools throughout the country without difficulty. As to if the students presently enrolled are concerned about accreditation, I don't think so, but I don't really know."

Columbia is already on the accreditation list of the Office of Education, the American Association of Collegiate Registrars and Admissions, the Association of College Admissions Counselors, the American Institute for Higher Education, and other organizations. The State of Illinois and other scholarship wielding organizations recognize the college.

But is accreditation important? What does it do?

To the school it attracts professors who might otherwise shy away, it opens the hearts and pocketbooks of philanthropic and government agencies (especially important since

For students, accreditation can prove important. The U.S. Civil Service Commission, state licensing boards and the military services often recognize only education from an accredited school, not to mention several employers who will not look at you without an accredited diploma.

Of all the colleges in the country 84% of them are accredited.

Accreditation cannot help us become better communicators, but according to the accrediting organization it can stimulate the school by making it look at itself. Thompson says that, "Accreditation strengthens education to meet the need of an individual in a rapidly changing society."

Columbia has recognized this as being one of the founding principals outlined in a self-study. Also listed are these principles: to provide a college education that enlists students' purposes and creative and social impulses as the instruments of their liberation. The goal is to help students learn to engage their full powers

education program needs reorder, too many students drop out, and the college government needs broadened participation, and more explicit protection of due-process.

"As we educate we need to constantly redefine our roles," says Davis. "That is what we are attempting through accreditation."

Despite the fact that the college is preparing itself for the visit President Mike Alexandroff says, "We intend to show ourselves at our best. We have no prompting, no particular statement, to urge any individual. Say what you will in good conscience.

"When the accrediting process was begun we emphasized our intention to achieve accreditation only if this could be accomplished without diminishing Columbia's integrity, uniqueness, and special purposes and without wasting ourselves in a search for the look and credentials of other colleges."

"We never will change ourselves for the purpose of gaining something from somebody else. We will not change the principals we have for

Accreditation, 1974. The college newspaper *CC Writer* reported that a seven-person team from the North Central Association would visit campus in November 1973 to decide if the college met the standards of excellence that the accreditation organization demanded from schools under its purview. The team's report after its visit on March 27, 1974, awarded Columbia College full accreditation from the NCA Higher Learning Commission. Celebrations took place in the president's office in the 540 North Lake Shore Drive building, where president Mike Alexandroff is seated and Hubert Davis, dean of Student Services, holds the banner. Icing on the cake spells out "We Done It." In 1984, Columbia's graduate programs were also awarded accreditation.

Four

IN THE SOUTH LOOP

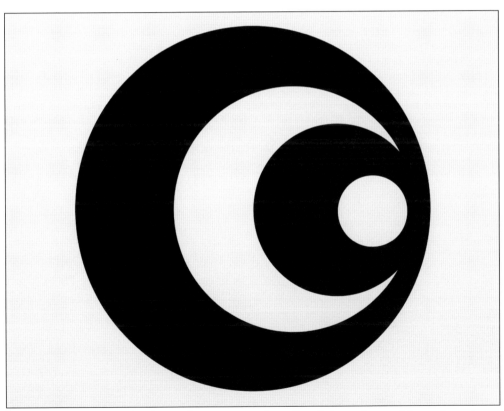

LOGO, 1973. As Columbia focused its mission, the college's logo changed from the twin worlds design to one that better reflected the times. The nested "C" was representative and fluid. Used on stationery, banners, posters, and the college newspaper *CC Writer* (see opposite page), this logo represented the school until 1980.

THE COLLEGE'S FIRST PROPERTY, 600 SOUTH MICHIGAN AVENUE. The college bought its first property in 1974, permanently establishing its campus in the South Loop. The building was constructed in 1906 and 1907 by Christian A. Eckstorm as the headquarters of the International Harvester Company. In 1937, it was purchased by the Fairbanks-Morse Company, makers of railroad engines, farm equipment, and hydraulic systems. The college began gradually occupying it in 1977. (Courtesy of Chicago History Museum.)

SOUTH LOOP, 1857. Twenty years after the city's incorporation, the area that is the South Loop today was mainly a modest residential enclave within walking distance to the central business district. This map shows the original shoreline of Lake Michigan, a few steps away from Michigan Avenue. The railroad right-of-way, on tressels over the lake in the foreground, is now sunk into Grant Park. (Courtesy of Chicago History Museum.)

SOUTH LOOP, 1898. The South Loop was spared in the Great Fire of 1871, but was obliterated in the second, and now largely forgotten, Great Fire of 1874. Here the influence of the railroad can be seen, with a good portion of the lake filled in to make way for tracks, and the familiar curve of the elevated tracks is visible at the intersection of Wabash Avenue and Harrison Street. (Courtesy of Chicago History Museum.)

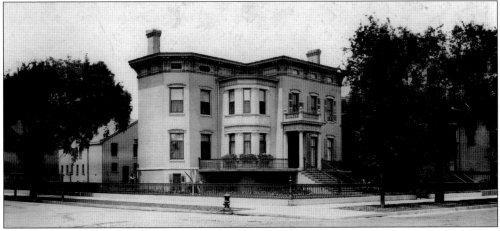

INTERSECTION OF MICHIGAN AND BALBO AVENUES, BETWEEN 1874 AND 1908. Looking northwest, this is the Blackstone mansion, home of railway magnate Timothy Blackstone. This photograph provides an inkling of what the mansion district, which arose along South Michigan Avenue after the second fire, looked like. Today this is the site of the Blackstone Hotel, named in Blackstone's honor. To the right is another mansion, on the grounds of 624 South Michigan. (Courtesy of Chicago History Museum.)

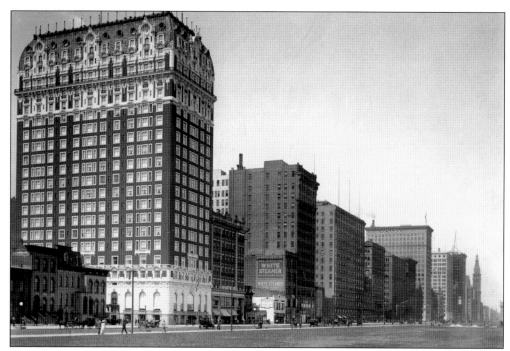

THE 600 BLOCK OF SOUTH MICHIGAN AVENUE, *c.* 1920. Many railways built stations in the area, and the influx of travelers led to the gradual demolition of the mansions and establishment of hotels and high-end shops. The second high-rise building from the left, 624 South Michigan Avenue, was built in 1908 to house the Chicago Musical College and the Ziegfield Theater. The college acquired this property in 1990. (Courtesy of Chicago History Museum.)

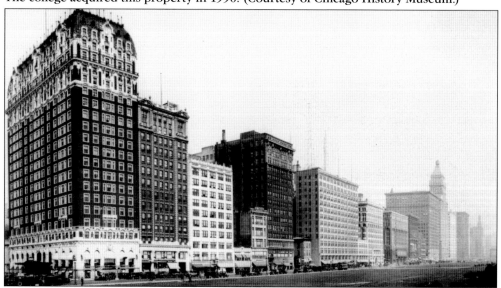

THE 600 BLOCK OF SOUTH MICHIGAN AVENUE, *c.* 1930. The mansions are nearly all gone at this point. Blum's Vogue, a high-end women's clothing boutique, bought the building at 624 South Michigan Avenue in 1922. In addition to adding seven floors to the structure, Blum's created a "building within a building" on floors one through six for their store. This space is now occupied by the college's bookstore and main library. (Courtesy of Chicago History Museum.)

THE 600 BLOCK OF SOUTH MICHIGAN
AVENUE, c. 1961. Blum's Vogue sold
the 624 building in 1962. It has
sported at least two illuminated
signs on the roof: first the Shell
sign seen in this image and, later,
one promoting Torco, another oil
company. The college removed it in
2004. IBM bought the 618 building in
1944 and reclad the facade in 1958. At
present, the college plans to replace
this facade yet again. (Courtesy of
Chicago History Museum.)

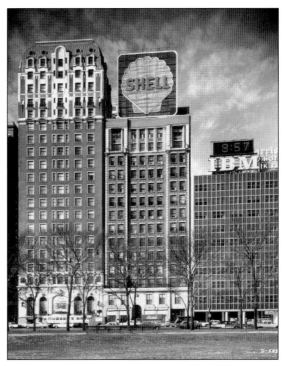

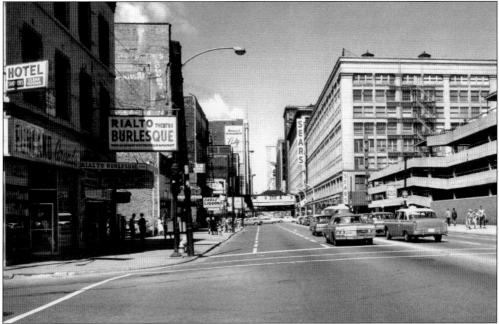

INTERSECTION OF STATE AND HARRISON STREETS, LOOKING NORTH, 1965. With the decline of rail
travel, the South Loop's fortunes suffered. The printing houses and boutiques moved out
and were replaced by establishments such as the flophouse, burlesque theater, and liquor
store seen in this photograph. Many buildings were razed for parking lots. The parking
structure on the right is the site of the University Center of Chicago (see page 125). (Courtesy
of Chicago History Museum.)

Columbia College Art Department Handbook

ART DEPARTMENT HANDBOOK, 1977. Issued to familiarize students with the new facilities, this handbook prominently displays 600 South Michigan Avenue at left. Other South Loop features of the time are also detailed in the background, including the elevated train, a "girly show," a hockshop, and a peep show. Art and photography gallery space on the first floor of the new building, which evolved into the Museum of Contemporary Photography, is mentioned.

SETTING UP THE LIBRARY, 1977. The main library was originally located on the 11th floor of the new building, before eventually occupying the second, third, and fourth floors. In 1995, the library was relocated to its present location in the "building within a building" on the first five floors of 624 South Michigan Avenue. The Center for Black Music Research, founded in 1983, created the first branch library in 1990.

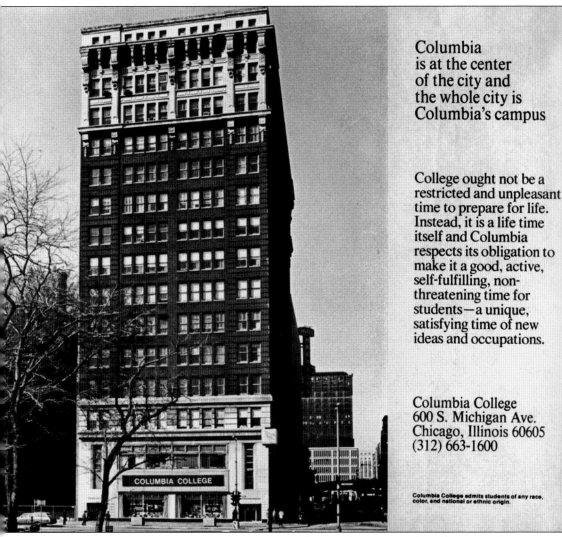

Columbia
is at the center
of the city and
the whole city is
Columbia's campus

College ought not be a
restricted and unpleasant
time to prepare for life.
Instead, it is a life time
itself and Columbia
respects its obligation to
make it a good, active,
self-fulfilling, non-
threatening time for
students—a unique,
satisfying time of new
ideas and occupations.

Columbia College
600 S. Michigan Ave.
Chicago, Illinois 60605
(312) 663-1600

COLUMBIA COLLEGE

PUBLICITY, 1982. Curriculum at the college continued to emphasize interdisciplinary studies. Bachelor of arts degrees were conferred upon graduation. Freely selecting courses of interest to create a meaningful education was paramount. Students could choose classes in film, photography, television, radio, theater, music, dance, graphic arts, craft arts, writing, poetry, journalism, humanities, literature, social sciences, and now, arts and entertainment business management. This brochure states, "Columbia is a place where you can try yourself out and freely explore what you can do and want to do." A quality liberal education designed to "inform and pleasure life" was combined with practical hands-on training received under the guidance of "inventive faculty who are leading professionals and scholars in the work of the subjects they teach." Today the college still adheres to these principles, offering students theory and practice, professional faculty, and creative spaces.

***Notebook of a Return to My Native Land,* 1976.** Students perform readings from noted francophone poet Aimé Césaire. The work chronicles Césaire's imagined return to Martinique from France and treats the ambiguities of Caribbean life and culture. It also marks the author's first foray into his exploration of *négritude* (black identity) and has become an anthem for black people around the world.

***Hair Trigger,* 1977.** Born out of the writing/English department, the Department of Fiction Writing was formally established in 1987. Structured around "the Story Workshop method of teaching writing," the program emphasized "the inter-relationships of processes of reading and writing, telling and listening, perceiving and communicating, critiquing and experiencing." Its annual publication, *Hair Trigger,* has won numerous awards since its first volume in 1977.

WCRX Broadcast, 1982. The college acquired WCRX (88.1 FM), its award-winning campus radio station, from the University of Illinois at Chicago in 1982. Known as "Chicago's underground radio," the station, which is student run and licensed as a noncommercial education station, serves as a laboratory for radio and broadcast journalism majors to gain practical experience. The station broadcasts from the 33 East Congress Parkway building lobby, observable through a window.

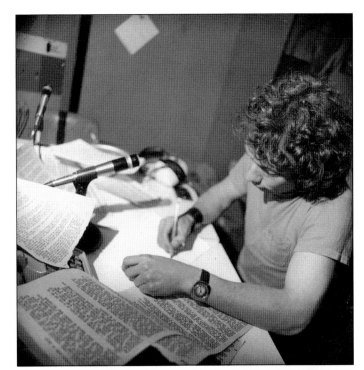

Typewriters, Early 1980s. Columbia did not teach typing, but much of the curriculum has been writing-based, such as journalism, advertising, and fiction writing. Until personal computers and laptops became widespread later in the decade, typewriters were the standard for document creation. The ones pictured here are less expensive manual versions, which would have required the use of correction fluid or correction paper to rectify typographic errors.

Logo, 1980.
The college logo underwent a change from its previous design in 1973. The embedded "C" is still present, but the perspective has been slightly altered. The design is lighter, with an optical illusion quality to it, seeming to rise to the upper left while simultaneously sinking to the lower right.

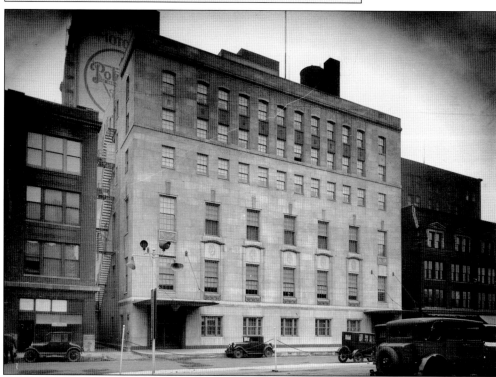

The Theater Center, 72 East Eleventh Street. Built in 1929 by Holabird and Root, this was originally the headquarters of the Chicago Women's Club. Subsequent owners and uses are unknown. Acquired by Columbia in 1980 as the school's Theater Center, it currently houses the renovated 400-seat Getz Theater, classrooms, and space for film and photography studios. The building on the left was demolished, and this lot is now the college's sculpture garden. (Courtesy of Chicago History Museum.)

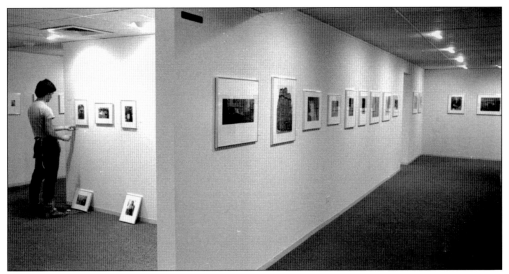

GALLERY SPACE, C. 1980s. The space currently occupied by the Museum of Contemporary Photography originally served as the college's first gallery on its new campus. Gallery space is always at a premium at an art school, and today the college operates numerous galleries, such as A+D, Arcade, C33, Center for Book and Paper Arts, Conaway Center, Glass Curtin, Hokin, Library, Quincy Wong Center for Artistic Expression, and Stage Two Center.

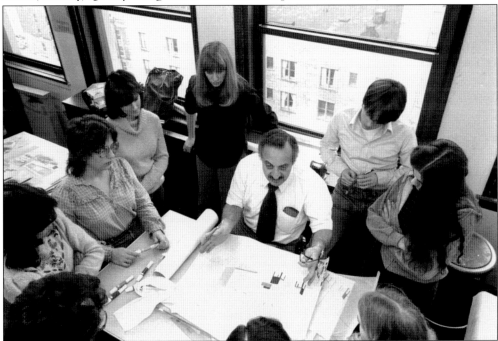

CLASSROOM, C. 1982. Classroom space was beginning to get tight as more students enrolled. The 623 South Wabash Avenue building was purchased in 1983, allowing the college to further expand. Also, graduate division programs offering a master of arts degrees in film and videotape; photography; interdisciplinary arts education; arts, entertainment, and media management; teaching of writing/creative writing; and dance therapy became accredited by North Central Association of Colleges the same year.

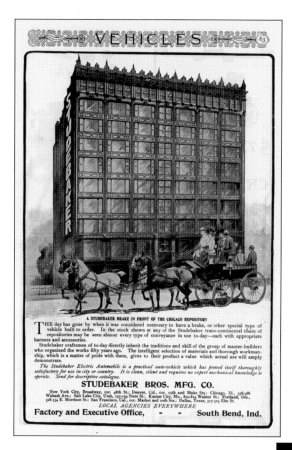

THE 623 SOUTH WABASH AVENUE BUILDING. Constructed in 1895 by Solon S. Beman, this building was originally built for the Studebaker Brothers Carriage Company as its Chicago regional office and warehouse. It was later owned by the Brunswick Company, makers of wood furnishings and built-in furniture. Acquired by Columbia in 1983, the name "Studebaker" still appears on the north side of the building, as does the Brunswick logo on the south wall.

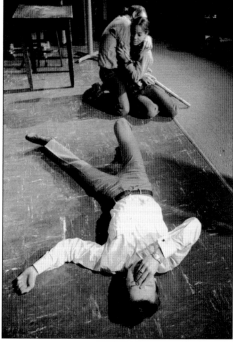

THEATER, c. 1982. The Department of Theater/Music offered training to equip students with necessary skills for a vocation in the performing arts. The music aspect of the department broadened the musical literacy of theater students while also supporting new music and innovative drama for the stage. Annual performances included a concert ensemble production, a classical play, a new American play, a new musical, a children's performance, and a visiting company production.

100

PUBLICITY STILLS, *C.* EARLY 1980s. Taken for a series of flyers, these pieces capture much of the college curriculum with dramatic black-and-white photography. The minimal text urges prospective students to "be educated to work successfully with word and story, with film, with sound, with brush, with loom, with potter's wheel" and touts the college as a place of collaboration, respect, and affection within a practical, professional setting.

ART AND DESIGN, c. 1980s. From its modest, yet earnest beginnings in 1970, with courses such as drawing, painting, and a theater arts workshop, the Department of Art began offering five specialized programs and more than 100 art courses by the mid-1980s. Its bold social agenda, however, had largely faded, and its primary objective was now to prepare students for entry-level work within their fields of interest or for graduate school where desired. In addition to traditional subjects, such as art history, drawing, and illustration, courses ranged from jewelry making to woodwork to furniture. The woman in the photograph at left spins clay on a wheel. The school had installed kilns by this point and taught firing as well. The woman below paints ballet slippers, using art to depict art.

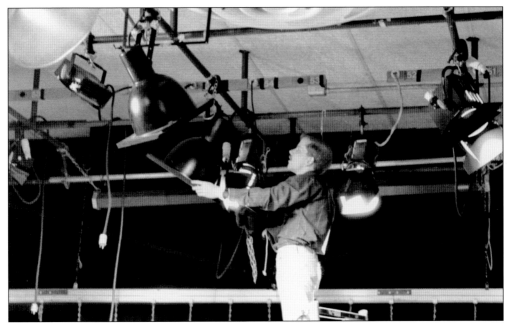

LIGHTING CLASS, C. 1984. Presenting a three-dimensional world on a two-dimensional screen and creating images to interpret a subject and clarify a filmmaker's statement were addressed, in part, through proper lighting. Lights had to be adjusted in order to bring film or video matter to life. Exterior lighting, use of reflectors, night, and day-for-night lighting were topics covered in this coursework. Designed to give students complete working knowledge of motion picture equipment, a student uses an Arriflex 16-mm camera, not to shoot film with sound, but strictly for staging the visuals properly within the frame and to make sure lighting was precise.

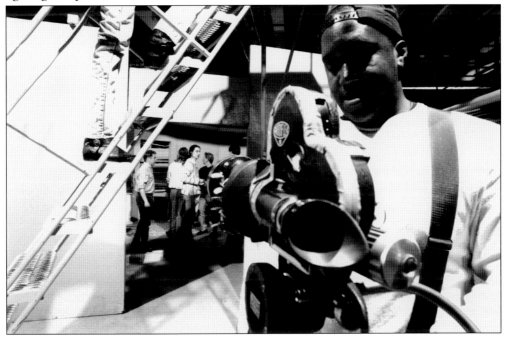

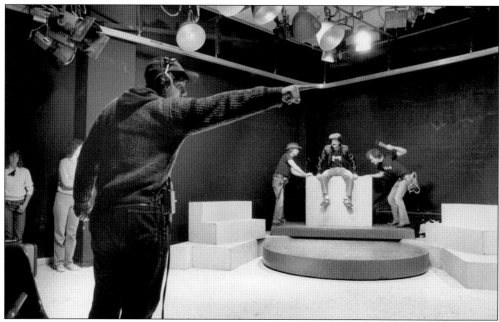

TELEVISION STUDIO PRODUCTION, C. 1984. The Department of Television at Columbia has been unique nationally in teaching the business of television and the practice of shooting television from behind the box. The program, begun in 1945, used nominal experts in the nascent industry who were barely more seasoned than their students. By the mid-1980s, the program had expanded to include new seminars in creative planning, the establishment of an interindustry planning board on curriculum, and a college video festival that became part of the television department's annual program. Columbia also purchased a three-camera mobile television unit so students could learn remote techniques in gathering news.

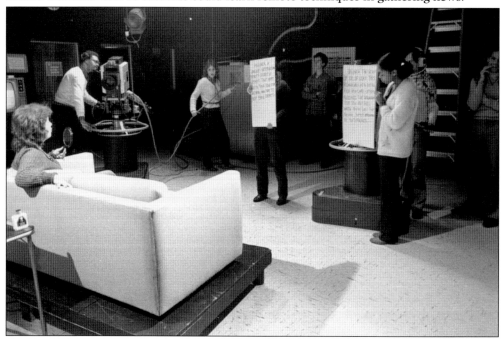

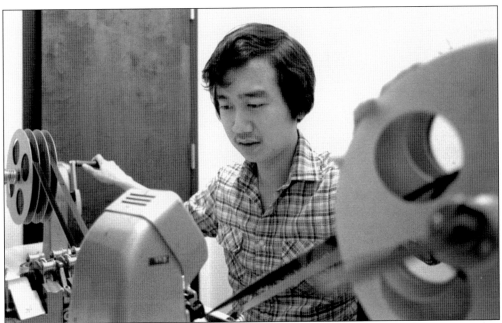

FILM/VIDEO DEPARTMENT, C. 1984. Editing film was just one skill that Department of Film/Video students learned. This department produced the annual Festival of Illinois Filmmakers to showcase the talents of local artists. It also presented screenings of students' work throughout the academic year. Through a joint venture with Facets Multimedia, a local nonprofit film and performing arts organization, high-quality film programming was presented two evenings a week in the 600 South Michigan Avenue building. Well-known directors, producers, screenwriters, and other industry professionals, such as John Cassavettes, Buck Henry, Dyan Cannon, Marcel Ophuls, and Steve Shagan, visited campus throughout the year. Such programs continue today.

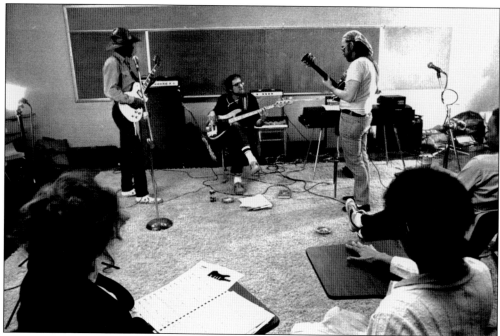

MUSIC INSTRUCTION, C. 1980S. Columbia's music program formally began with the creation of the Center for New Music in 1965. The center originally focused on the composition and performance of contemporary music, and the Chicago Jazz Ensemble served as its cornerstone and professional workshop orchestra. Today music is one of the larger disciplines on campus, offering seven undergraduate concentrations and one of only two programs in the United States offering a master's degree in scoring music for the screen. These images show classroom instruction in electric guitar and students practicing piano. Both group instruction and one-on-one instruction have been a part of the curriculum from its founding.

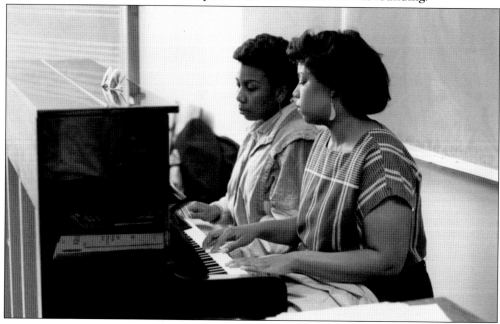

FILM EDITING, *C*. EARLY 1980s. By the early 1980s, the college still offered its whole college process of learning, with emphasis on coursework based on a student's interests, but gave students the option to study courses in one major field. The 48-credit requirement for general education courses was still in effect, and most majors required 60 credit hours of core curriculum.

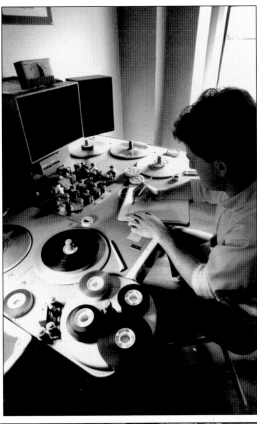

WCRX, EARLY 1980s. With highly technical majors, such as radio, television, and film, Columbia students have dealt with complex technology for decades. Here a variety of radio and sound-recording technologies can be seen, many of them now obsolete. Columbia's expanded offerings, such as the introduction of game design, and its status as a leading arts and media college compel it to maintain state-of-the-art laboratories and studios.

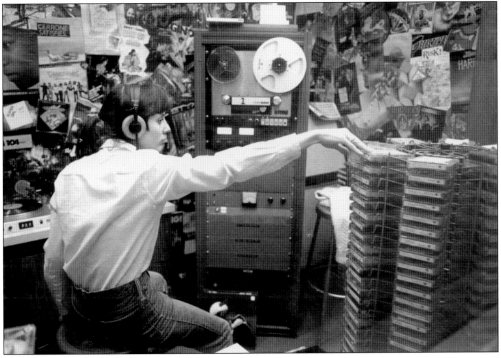

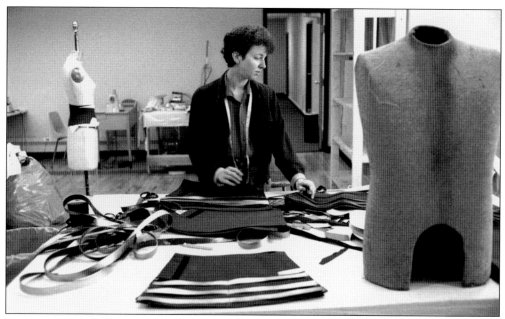

FASHION, C. 1992. Classes in the fundamentals of patternmaking, garment construction, and menswear design were offered in 1992. More coursework was added at the college in the field of fashion throughout the 1990s. Beginning as classes in the art and design department, fashion coursework blossomed into two concentrations centered in two departments: the arts, entertainment, and media management (AEMM) department and the art and design department. The fashion design concentration was offered through the Department of Art and Design; the fashion/retail management concentration was offered through the AEMM department. In 2010, in response to the success of these two fashion concentrations, the college established the Department of Fashion Studies.

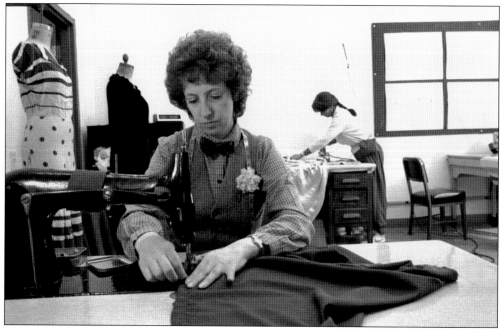

SCIENCE INSTRUCTION, *c.* 1980s. Columbia developed a unique science curriculum designed specifically for arts, media, and communications students. Based upon the philosophy that science is more meaningful if concepts are explored using a variety of art forms, the primary objective of the program is to equip students with a comprehensive background and explore actual science-related problems that students will encounter in their respective fields. Thus, photography embraces physics and chemistry, while dance relates to anatomy and physiology. A second objective of the program is to educate students so that they can participate knowledgeably in the national debate of science-related issues, such as energy policy or biomedical ethics. Beginning in fall of 2011, the Department of Science and Mathematics will offer its first degree, in arts and materials conservation, one of only three such programs in the country.

PHOTOGRAPHY

**PROFESSIONAL PHOTOGRAPHERS'
SEMINAR**

**Held at Columbia College
June 13, 14, 15, 1980**

SEMINAR ADVERTISEMENT, 1980. Columbia has held many conferences and seminars, like the one advertised here, but none received perhaps as much attention as the Arts and the Inner City conference in 1968. This conference was predicated on the idea that arts programs in the inner city at that time were designed by outsiders and had little relevance to the people they were aimed at teaching. The Coalition of Black Revolutionary Artists protested the event, which drew national media attention.

PHOTOGRAPHY, C. MID-1980S. Through a mix of foundation courses, the photography program taught technical competency while providing the aesthetic stimulation to allow students to achieve creative involvement and output. Three specialized programs were available: fine arts photography, photojournalism, and professional sequences. Departmental space tripled with the addition of new studios and darkrooms. Instruction in black and white, color, dye transfer, lithography, and graphic arts was also offered.

PHOTOGRAPHY, C. EARLY 1980S. An 8-inch-by-10-inch camera was used to shoot a photograph in a college studio. At this time, there were 28 full-time and part-time faculty members; today the department has nearly 85 faculty and staff members. The Museum of Contemporary Photography, one of two fully accredited photography museums in the country, grew out of this department and is a separate entity at the college.

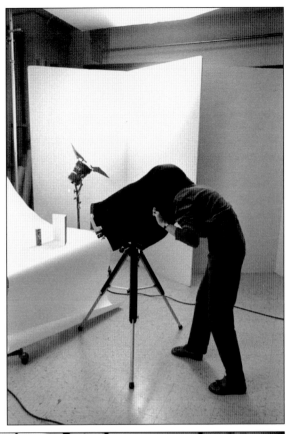

STAGE COMBAT, C. 1980S. Stage combat first appeared as a separate course in 1985, designed to teach realistic and safe techniques for various types of combat on the stage. Today this subject is a four-course sequence, with the ultimate goal of passing a skills test with the Society of American Fight Directors.

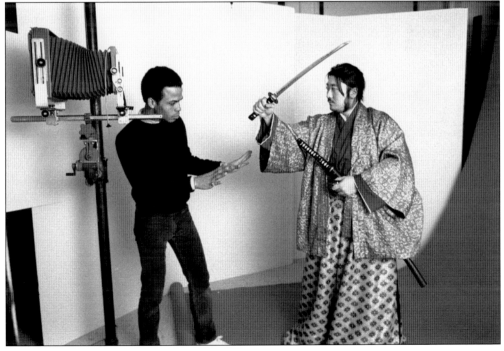

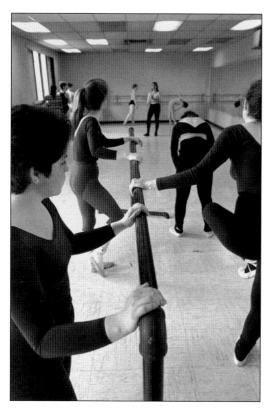

DANCE, C. 1980s. Dance was introduced into the curriculum in 1970 with the founding of the Dance Center. In its first year, course offerings were limited to a series of five workshops. By the time these photographs were taken, nearly five times that number were being offered. These ranged from traditional ballet (left) to modern idioms, such as tap and jazz dance (below). Other courses included African dance forms, tai chi, a course on shooting dance video, and a number of dance therapy choices. Dance therapy eventually became a separate master's program. From 1972 until renovations were completed on the new Dance Center in 2000 (see page 121), the Dance Center operated far off campus in a theater building at 4730 North Sheridan Road.

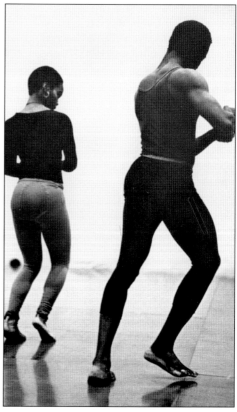

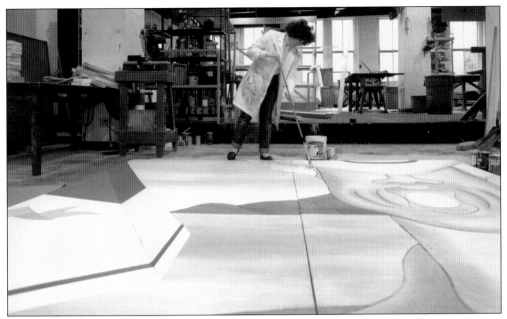

LARGE-SCALE ARTWORK, C. LATE 1980s. Since the late 1960s, large-scale artwork has been produced by the college community. Murals, created collaboratively by Columbia students and neighborhood residents, decorated local communities. With Chicago-as-classroom, students readily created large-scale art, which the college still does today. A recent collaboration to create public art was the Harrison Street Red Line Station Haiku project in 2008. Composed by poetry students from Columbia and Jones College Preparatory High School, it transformed the subway station, the primary gateway to Columbia's campus. Columbia galleries traditionally have been filled with large-scale prints. The Museum of Contemporary Photography, in partnership with the Center for Community Arts Partnerships, annually showcases installations created by Chicago schoolchildren.

Columbia Chronicle

Volume 14 Number 18 MARCH 11, 1985 Columbia College, Chicago

Columbia exceeds founders' goals

By Dennis Anderson and Carolyn R. Hamilton

COLUMBIA CHRONICLE, 1985. The college's free student newspaper is published weekly throughout the school year. Begun in 1979, the *Chronicle* prides itself on a strong appreciation for design and its aesthetically pleasing layout as well as the multiple awards it wins annually. This issue, dated March 11, 1985, leads with a cover story about the college's history, a topic of ongoing interest within the Columbia community.

MOBILE BROADCAST UNIT, 1985. Columbia acquired a mobile broadcasting unit, a classroom-on-wheels, with equipment designed to facilitate reporting and broadcasting on or off campus. The traveling truck enabled students to learn on location and report news where it happened. It drew a crowd when students focused cameras from atop its roof. The college still utilizes such units for teaching students field skills.

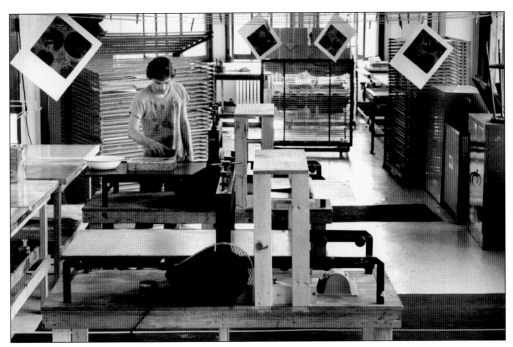

LITHOGRAPHY, C. EARLY 1980s. One course within the art department was lithography, a printmaking method using stone. An artist carves designs onto a stone, inks it, and then impresses the design onto paper. Shown here is a lithography studio replete with racks to dry each work. The college continues to offer courses in this method and partnered with Anchor Graphics in 2006, whose mission is to educate people in hand-printmaking techniques.

SCIENCE, C. 1980s. To appreciate contemporary science in the life of individuals and society, the college offered coursework in the sciences beginning in the 1960s. This exhibit, featuring a crystalline molecule, highlights the science behind the arts. Today the college supports the science and mathematics department, whose mission is to provide students with a comprehensive background in scientific and mathematical thought.

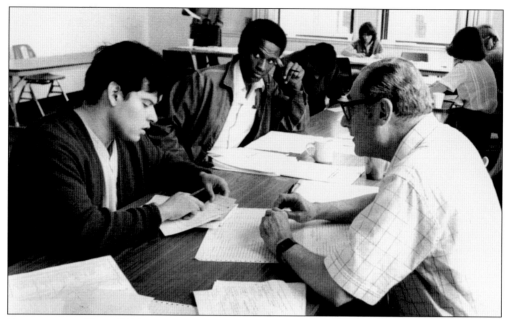

REGISTRATION, FALL 1984. Registration at Columbia was not fully automated until the 21st century. Prior to that, it was a lengthy and arduous undertaking, especially as the student population continued to grow. It was not uncommon to see lines of students snaking through halls and winding down stairways. Here a student seeks help from an advisor to prepare his schedule.

MIKE ALEXANDROFF, 1991. An avid White Sox fan, Mike Alexandroff pitched the first ball at the game on July 24 between the Sox and the Toronto Blue Jays. During his tenure, the college received accreditation from the North Central Association Higher Learning Commission, established a graduate division, and purchased the college's first building, today named in his honor. He served on many local organizations, receiving an honorary doctorate from DePaul University.

Five

FORWARD MOMENTUM

LOGO, 1997. The familiar 1980 logo with its tilted and embedded "C" was altered when the college officially changed its name from Columbia College to Columbia College Chicago. The word "Columbia" was added to the design to reflect the three-"C" name. This logo replaced the previous one on stationery, publications, and college gear.

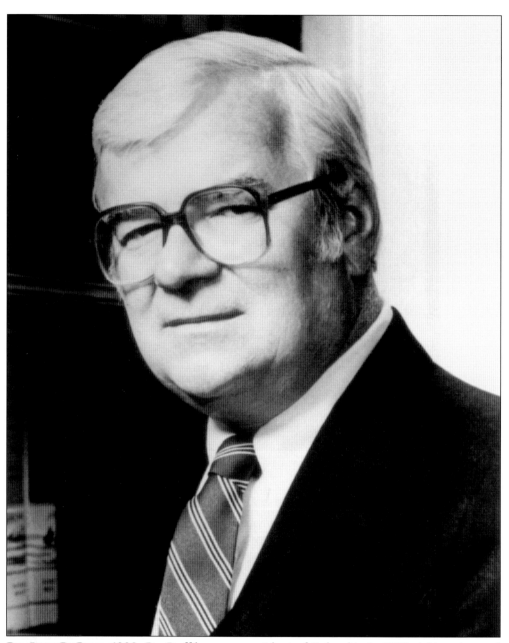

DR. JOHN B. DUFF, 1993. Dr. Duff became president of Columbia in 1992. A historian and author, he was educated at Fordham University, New York; Seton Hall University, New Jersey; and Columbia University, New York. He oversaw the acquisition of the college's first modern residence hall, led its first long-range planning effort, expanded its local and national development initiatives, and changed the name of the school to Columbia College Chicago. Before Columbia, he was the first nonlibrarian appointed as commissioner of the Chicago public library system and supervised the construction of the Harold Washington Library. He served as the first president of University of Massachusetts-Lowell and the first chancellor of the Massachusetts Board of Regents. He sat on many local boards, including the Federation of Independent Illinois Colleges and Universities.

THE 731 SOUTH PLYMOUTH COURT RESIDENCE HALL. Built in 1897 by Howard Van Doren Shaw and originally called the Lakeside Press Building, it served as a printing house for the R. R. Donnelley Publishing Company. The building is an integral part of the South Loop Printing House District. It was converted to residential use as the Lakeside Loft Apartments in 1985 and acquired by the college in 1993 as its first modern residence hall.

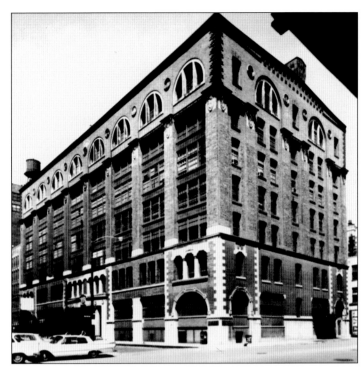

MOVE-IN DAY, 1993. The first dormitory space provided by the college since the 1920s, Plymouth Court currently houses more than 300 students. The motivating factor in its purchase was the growing need to provide housing for the school's swelling international and out-of-state students who might not have considered Columbia if housing were not an option. Currently, about 2,100 students (nearly one-fifth of the student body) live on campus.

Dr. John B. Duff, 1994. Dr. Duff stands outside the Museum of Contemporary Photography, the college's only museum and the only museum in the Midwest with an exclusive commitment to the medium of photography. Founded in 1984, it presents projects and exhibitions that embrace a wide range of contemporary aesthetics and technologies, while striving to communicate the value and significance of photographic images as expressions of human thought, imagination, and creativity.

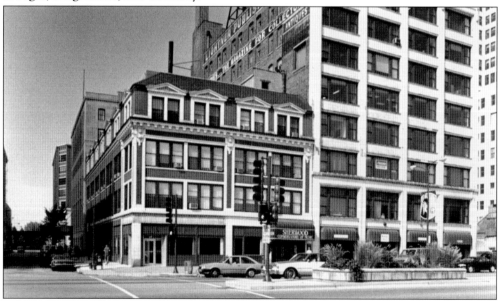

The Music Center, 1014 South Michigan Avenue. Constructed in 1912 by Christian Eckstorm as a speculative commercial building, the structure housed offices for a shingle distributor, a lumber company, and an electrical parts manufacturer. In 1941, the building was rehabilitated for the Sherwood Conservatory of Music, which was founded in 1895 and merged with the college in 2007. The building itself was acquired by Columbia in 1997 and houses the music department. (Courtesy of Chicago History Museum.)

THE FILM CAGE, C. EARLY 1980s. Students and staff inspect the Bolex 16-mm film cameras students used to create their first films. For decades, film cage workers have been responsible for distributing, inspecting, and repairing cameras and lighting kits for students' use during the semester. The cage functions with precision. This is many students' first experience with the rigid scheduling that is often found on a professional film set.

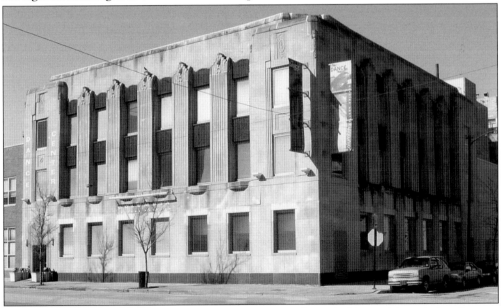

THE DANCE CENTER, 1306 SOUTH MICHIGAN AVENUE. Built in 1930 by architect Anker Graven, this Art Deco building was erected as the Paramount Publix Corporation film exchange, a venue for film presentations and rentals for cinema operators. Later housing an insurance company, a union headquarters, and a health clinic, the building was acquired by the college in 1999 for use as the school's Dance Center, which opened in 2000 after extensive interior renovations.

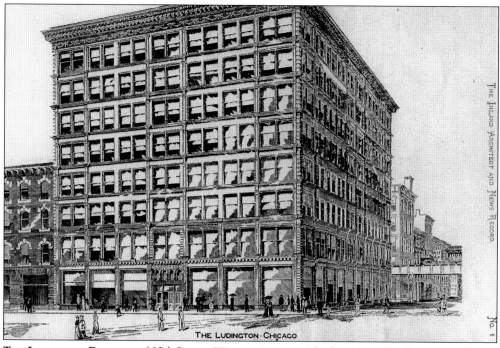

THE LUDINGTON·CHICAGO

THE LUDINGTON BUILDING, 1104 SOUTH WABASH AVENUE. The landmark Ludington Building, the first entirely terra-cotta-clad skyscraper in history, was built in 1891 by William LeBaron Jenney for the American Book Company to house its offices, printing presses, and packaging and shipping operations. It was purchased by the college in 1999 and houses the Center for Book and Paper Arts, the Glass Curtain Gallery, the Conaway Multicultural Center, and Film Row Cinema.

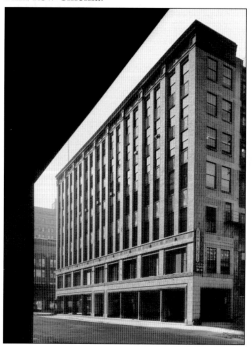

THE 33 EAST CONGRESS PARKWAY BUILDING. Built from 1925 to 1926 by Chicago architect Alfred Alschuler, the Congress-Wabash Building initially housed a bank, offices, and recreation rooms that included a pool hall. In the 1980s, it became the home of MacCormac College. Columbia leased space in the building starting in 1997 and purchased the structure in 1999. It currently houses classroom space, the *Columbia Chronicle* offices, and WCRX, the college's radio station. (Courtesy of Chicago History Museum.)

DR. WARRICK L. CARTER. Dr. Carter joined Columbia in 2000, following a four-year term as director of entertainment arts for Walt Disney Entertainment, where he was responsible for developing global education and live arts programs for the corporation. Prior to that, he spent 12 years at Berklee College of Music in Boston, Massachusetts, serving as dean of faculty and then as provost/vice president of academic affairs. Before his time at Berklee, Dr. Carter was at Governors State University in University Park, Illinois, where he began as a professor of music and was promoted to chair of the division of fine and performing arts. He began his career in higher education as an assistant professor and director of bands at the University of Maryland, Eastern Shore, teaching there while obtaining a doctorate of philosophy in music education from Michigan State University, East Lansing, Michigan. Dr. Carter is an educator, composer, and performer. He has consulted on music education and minority issues in music education for organizations worldwide. (Photograph by Bob Kusel.)

THE PRESIDENTIAL MEDALLION. This medallion is worn by the president during commencement ceremonies. It is made of silver and was created by Miklos P. Simon, a Chicago-based sculptor and adjunct Columbia faculty member. The medallion was designed and crafted in stages between 2006 and 2009. Each element was hand-sculpted in clay, refined in dental stone, and cast in silver. The large disc on the bottom is the official seal of the college. At its center, the 1964 logo (see page 59) is depicted on a scroll or book (ancient wisdom), which surrounds a torch (the light of truth or intelligence). A sunburst (creative energy) shines from behind. Above the image is the college's motto; below are the year of its founding and a laurel wreath (honor). The eight smaller coins are portraits of the college's past presidents. The underlying symbolism of the medallion is that over time the portrait of each new president will add weight to the medallion, representing the weight of Columbia's history, increasingly brought to bear by each future president.

DR. WARRICK L. CARTER. Dr. Carter holds an international reputation as a performer and composer. A two-time recipient of the National Black Music Caucus Achievement Award and a member of the International Jazz Educators Hall of Fame, he has published and lectured on the arts, music education, jazz, and African American music history and has consulted on music and arts education and minority issues in the arts for organizations worldwide. (Photograph by Robert Drea.)

THE "SUPERDORM," 525 SOUTH STATE STREET. Built between 2002 and 2004 in conjunction with DePaul and Roosevelt Universities, the University Center of Chicago, also known as the "Superdorm," houses 1,700 students and is the largest multi-school residence hall in the country. In addition to street-level retail establishments, the center provides students with a food court, a rooftop garden, and a workout facility. The center helped transform Columbia into a 24-hour residential campus.

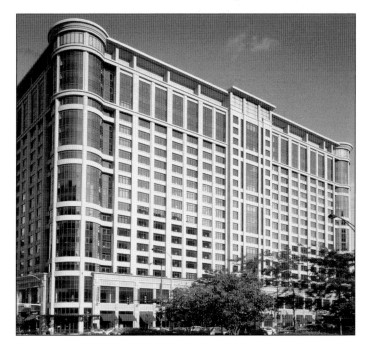

MANIFEST. Begun as MayFest in 2002, the college's annual urban arts festival celebrates the next generation of artists and creative professionals by highlighting capstone projects from more than 2,000 graduating seniors, including art and photography exhibitions, theatrical and media displays, street performances, original films, gaming design, and literary readings. Additionally, outdoor stages pulse with the sounds of student bands throughout the day. Past years have also featured the Spectacle Fortuna parade. In 2010, this was replaced with Convergence, a visual feast that included giant rolling drum machines, a 100-student performance ensemble, an astronaut shot toward the stars, and a fusion of fantastic features, all contributing to lending the performance a carnival-like air. Manifest is held immediately before commencement. Along with convocation, which occurs just before school begins in August, Manifest and the commencement bookend Columbia's academic year.

THE 1327 SOUTH WABASH AVENUE BUILDING. The former office of Famous Players-Lasky Corporation, the parent company of Paramount Pictures, was designed by Rapp and Rapp and built in 1923. When this building was slated for demolition, the City of Chicago approached the college to have the entryway arch preserved and included in the lobby of the new Media Production Center as a reminder of Chicago's filmmaking history.

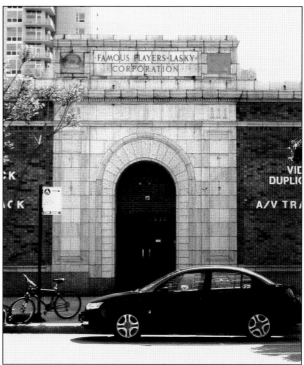

THE MEDIA PRODUCTION CENTER, 1600 SOUTH STATE STREET, 2010. The Media Production Center is Columbia's first newly constructed building. The innovative 35,500-square-foot facility comprises two soundstages, a motion-capture studio, an animation lab, four classrooms, and spaces for production design, costumes, and equipment storage. Additionally, the building incorporates an innovative use of mechanical systems, has a 50 percent green roof area, and uses sustainable materials wherever possible.

www.arcadiapublishing.com

Discover books about the town where you grew up, the cities where your friends and families live, the town where your parents met, or even that retirement spot you've been dreaming about. Our Web site provides history lovers with exclusive deals, advanced notification about new titles, e-mail alerts of author events, and much more.

MADE IN THE

Arcadia Publishing, the leading local history publisher in the United States, is committed to making history accessible and meaningful through publishing books that celebrate and preserve the heritage of America's people and places. Consistent with our mission to preserve history on a local level, this book was printed in South Carolina on American-made paper and manufactured entirely in the United States.

This book carries the accredited Forest Stewardship Council (FSC) label and is printed on 100 percent FSC-certified paper. Products carrying the FSC label are independently certified to assure consumers that they come from forests that are managed to meet the social, economic, and ecological needs of present and future generations.

FSC
Mixed Sources
Product group from well-managed forests and other controlled sources

Cert no. SW-COC-001530
www.fsc.org
© 1996 Forest Stewardship Council

Find Your Place in History.